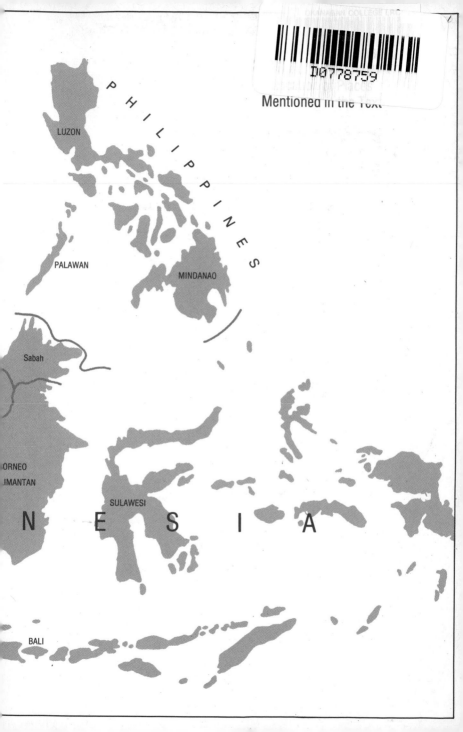

PHILIPPINES

LUZON

PALAWAN

MINDANAO

Sabah

BORNEO
KALIMANTAN

SULAWESI

N E S I A

BALI

Folk Pottery
in South-East Asia

DAWN F. ROONEY

SINGAPORE
OXFORD UNIVERSITY PRESS
OXFORD NEW YORK
1987

Oxford University Press

Oxford New York Toronto
Petaling Jaya Singapore Hong Kong Tokyo
Delhi Bombay Calcutta Madras Karachi
Nairobi Dar es Salaam Cape Town
Melbourne Auckland

and associates in
Beirut Berlin Ibadan Nicosia

OXFORD is a trademark of Oxford University Press

© *Oxford University Press Pte. Ltd. 1987*

ISBN 0 19 588866 9

Printed in Singapore by Kim Hup Lee Printing Co. Pte. Ltd.
Published by Oxford University Press Pte. Ltd.,
Unit 221, Ubi Avenue 4, Singapore 1440

To Jim and Sarah

Preface

THE idea for this book originated several years ago in Bangkok, Thailand, when I was looking at ceramics in the antiques market, conscious of the infinite variety of wares available. Collectively, they represented many cultures and spanned 6,000 years. Some were beautiful and refined, others were crude and roughly finished. Some were produced in the region, others were imported from China, Vietnam, or Japan. Yet, stylistically, the pieces were linked by a common thread. All were made to be used; not a single piece was purely decorative. The impression of functionalism was strong. These wares were most certainly the everyday utensils of the early inhabitants of South-East Asia.

No previous study had been published on this relatively unknown field of folk pottery. Where were the wares made? What were their dates of production? How were they used? By whom were they made? I believed that research into answers to these questions would be of interest and value to readers on many levels, including serious collectors and ceramic historians.

Knowing that utilitarian shapes are often produced repeatedly over a long period of time, I started my research into the growth and development of pottery production by looking at contemporary ceramics made in the region in the hope of finding similarities between modern and ancient shapes. My findings are contained in this book. I learned that modern wares provide a vital link to the past through the reproduction of antique shapes, glazes, and designs. Today, inspired by ancient wares, modern copies support a thriving industry that has grown rapidly in the past five years. Paralleling this movement, is the production of earthenware utensils for daily use.

New shapes and designs are being made, reflecting the creativity of today's craftspeople.

The photographs in the book show the variety of utilitarian wares from prehistoric times to the twentieth century and are a visual record of the extensive use of pottery in South-East Asia. The historical and social environment in which the ceramics were used is also illustrated.

The text reveals the riveting story of folk pottery in South-East Asia and the burgeoning production of modern copies. It introduces lesser known types of ceramics that have been found on the shores of mainland and insular South-East Asia, to the delight of treasure hunters.

The awareness and appreciation of these wares by collectors will most certainly increase with the current trend towards a preference for more basic, earthy types of pottery. Since pieces are still available in the market, these wares should be of particular interest to the assiduous collector.

Most of the ceramics discussed in this book have been found during the last twenty years. It is probable, therefore, that the main story of the development and growth of pottery in South-East Asia still lies beneath the ground, awaiting discovery.

London, 1987 DAWN F. ROONEY

Acknowledgements

My sincere thanks to Vance Childress for the line drawings, John Everingham for donating his photographs, Natalie Robinson for research material on the unglazed wares, Michael Smithies for advice on the manuscript, and to Charnchai and Orawan Suphanichvorapach, Gwyneth Chaturachinda, S. S. Chua, Cris Kellstrom, and Elizabeth Moore for their assistance and support.

All photographs in the book are by the author unless otherwise stated.

Contents

I

Introduction

Background

SOUTH-EAST ASIA abounds with appealing utilitarian pottery. Robust, balanced forms made for domestic use are an integral part of daily life. Closely aligned to the elements of nature, the pottery reflects the cultural and religious heritage of the people of the region.

Folk pottery produced in South-East Asia has been neglected in reported finds, analyses, and published references. Even though earthenware shards are found at the majority of archaeological excavations in the region, they are frequently cast aside in favour of salvaging other materials such as stone and bronze, which vary more in style and thus provide an easier standard for dating.

Folk pottery imported into South-East Asia has been equally neglected. Large quantities were transported, first from China, and later from Japan, over a long period of time. However, they have received minimal attention and study.

'South-East Asia' is a twentieth-century term used to identify a geographical area situated east of India and south of China. It consists of a mainland region corresponding to the present-day countries of Burma, Cambodia (also known as Kampuchea), Laos, Thailand, and Vietnam, and an insular region constituting Brunei, Indonesia, Malaysia, the Philippines, and Singapore. In ancient times, the area was called 'Nanyang' or 'Nan-hai' (South Seas) by the Chinese. On early maps drawn by European cartographers in the sixteenth century, any geographical area east of India was named generically. South-East Asia was identified in broad terms,

such as 'Further India', 'East India', 'India Outside the Ganges', or 'The Orient Beyond India'. A miniature map of 1599 by Giovanni Botero (1540–1617) shows South-East Asia in remarkably good proportions, particularly the coastline of the mainland region (Colour Plate 1).

The percept that pottery origins in South-East Asia were long-standing emerged in the mid-1960s with the discovery of unglazed earthenware on the northern Khorat Plateau in north-eastern Thailand, which revealed an extensive pre-historic civilization previously unknown. The finds, collectively called the Ban Chiang cultural tradition after a village in the region, have produced quantities of earthenware pots that were used for cooking, storage, and funeral rites. Sites that have yielded Ban Chiang pottery encompass a large area extending well beyond the village of Ban Chiang, and confirm that the technology for making pottery was known in the pre-historic period.

Everyday earthenwares found in Brunei, Burma, Cambodia, Indonesia, Malaysia, the Philippines, and Thailand have certain features in common. Even the earliest pieces reflect a combined utilitarian and aesthetic appeal, a characteristic often found in other arts and crafts of the region. Much of the indigenous pottery was made by craftspeople who worked in slack periods of the agricultural season using local materials to produce wares for everyday use. The region is abundant in the natural elements required for making pottery. Undoubtedly, this rich source accounts for the preference of fired clay over other materials for domestic vessels. Production of pottery for utilitarian use continues today in South-East Asia and the methods and materials remain basically unchanged.

A stylistic comparison of earthenwares from prehistoric to modern times suggests that production has been uninterrupted, but archaeological support is lacking. Problems in providing evidence include determining dates of production and place

of origin. Since the wares were made for use by the local population rather than for export, the same shapes were produced over a long period of time with little stylistic change. Also, because of their portability, they are frequently found away from the place of origin. Additionally, unlike imperial wares, there are no models to study and museums rarely display folk pottery. Even though continuous habitation has not been established, a succession of cultures within the region is identifiable. The gaps in evidence may be due to a lack of attention to pottery in excavations rather than a stop in production.

The development and level of technological achievement of pottery production in South-East Asia varied amongst the countries. Vietnam reached the highest degree of skill at the earliest date. Unlike other countries in the region, the knowledge of making pottery was most likely transferred directly from China to Vietnam in the beginning centuries of the Christian era. Similarities in the methods of potting, in shapes, and in decoration are evident between wares from the two countries. Pottery technology in Indonesia, Malaysia, and the Philippines, did not advance until modern times beyond the production of unglazed, utilitarian wares. In other countries, notably Cambodia and Thailand, development was probably a gradual one evolving through the refinement of natural materials and improved skills in techniques of decorating, glazing, and kiln construction. Both countries produced low-fired, unglazed earthenware and high-fired stoneware, unglazed and glazed.

Not all folk pottery in South-East Asia is indigenous. Local production was paralleled by imported wares as early as the tenth century. Chinese celadons from the Song period (960–1279) have been excavated in Indonesia and the Philippines. However, it was from the fourteenth century onwards, with the introduction of blue and white, China's greatest ceramic

achievement, that the largest quantities of folk pottery were imported into South-East Asia.

Terminology

In this book, the terms 'pottery' and 'ceramics' are used inter-changeably and apply to all fired clay objects, unglazed or glazed, and include earthenware, stoneware, and porcelain. Classification of pottery types is based on body material, not on the glaze, and the primary difference is the temperature at which the wares are fired. Mention of colour and texture of the clay body refers to the visible unglazed areas after firing.

Earthenware is the earliest type of pottery made by man-kind. It is usually unglazed and the colour varies widely from shades of grey to buff to reddish-orange. The texture is coarse and porous so it is easily broken, which is probably why so little early earthenware has survived. It is relatively simple to make, requiring only an ordinary clay and a simple open pit for firing.

Stoneware is the next stage in the development of fired clay. The characteristics of stoneware vary more than any other type of pottery because of the natural materials used. The clay is usually more complex than earthenware, with substances added to improve it. The colour varies from buff to orange to light and dark shades of grey, depending on the clay used and the firing conditions. It is fired at a higher temperature than earthenware, making it a harder and more durable material. Stoneware is usually glazed.

Porcelain is a refinement of stoneware and the final achieve-ment in the development of pottery. It was made in China as early as the third century AD. The formula for producing porcelain remained a secret until the seventeenth century when Europe starting making a counterpart. Technically, porcelain is synonymous with perfection. It is always glazed

4

and the clay is white due to the presence of an ingredient called kaolin. It is fired at a very high temperature which produces a hard, impervious body that is translucent.

It is not always easy to distinguish between stoneware and porcelain without laboratory testing. In some cases, especially with blue and white folk pottery, a piece of each type side by side can look the same, yet one is porcelain because it was fired at a higher temperature than the other one which is stoneware. Both types are high-fired and impervious. In general, stoneware is more thickly potted and opaque with a greyish tinge to the clay, whereas porcelain is thinly potted, translucent, and white. In perfect condition, it is possible for both types to ring when struck.

2

Development of Pottery in South-East Asia

Prehistoric Wares

PREHISTORIC earthenware vessels were closely linked with the ceremonial and ritualistic customs of the people. Whole and broken pieces found in burials have produced valuable information about the sociological aspects of the early inhabitants of the region.

A comparison of artefacts from various sites indicates cultural links between prehistoric groups in the region. In addition to pottery, similar metal tools and glass beads have been found at sites in Indonesia (Borneo), Malaysia (Sabah and Sarawak), the Philippines, and Thailand.

Typical pottery of the prehistoric period in South-East Asia is an earthenware vessel, hand built with coils, and finished with an anvil and beater. Although there is evidence that some of the vessels may have been turned on a wheel for decorating, full use of the potter's wheel was employed at a much later date. The vessel is medium sized, with a globular body, wide mouth, and round bottom. It was fired at a low temperature in an open pit, which produced various earth tones on the exterior. The vessel was often finished with a combination of cord marking and incised geometric designs. The early vessels of the region are surprisingly pleasing to the eye and well constructed, with balanced proportions.

Identified prehistoric sights in Cambodia date to the fourth millennium BC. Collected artefacts are similar, both stylistically and in apparent use, to those found in other parts of the region.

Prehistoric earthenware burial vessels have been found in

caves in Malaysia at Sabah. Evidence shows that firing of the wares took place inside the caves, an ingenious forerunner of the kiln.

Pottery has also been found inside a cave on the island of Palawan, in the south-western part of the Philippines. The cache of decorated ritual vessels are dated to the first millennium BC. Burial sites in the Philippines have produced pottery dating from the middle of the second millennium BC.

The prehistoric Ban Chiang culture in Thailand extends from about the fourth millennium BC to the third or fourth century AD. However, since bronze and iron artefacts found in association with pottery represent products of a highly developed metal industry, it is possible that additional discoveries may produce an earlier date for the beginning of prehistory in Thailand.

A characteristic vessel of the late Ban Chiang period is a large upright pot with sharp angles, a wide flaring rim, and a pedestal. It was made from a dark clay and covered with a buff slip. An asymmetrical geometric motif combining thick and thin lines was boldly painted with red vegetable dye on the body.

Historic Wares

UNGLAZED

Little is known about the development of earthenware in South-East Asia in the early historic period. It is likely that a common type of utilitarian ware was made throughout the region since similar shards from this period have been found in Burma, Cambodia, Indonesia, Malaysia, the Philippines, Thailand, and Vietnam. A comparison of shape, method of potting, and decoration of the few reported finds, indicates that vessels continued to be made in the prehistoric tradition.

Unglazed earthenware has been excavated from Dvaravati

period (seventh–eleventh centuries) sites occupied by the Mons in central Thailand. Most of the vessels were thrown on a potter's wheel, so it is evident that a development in technology from hand building and coiling to the wheel had already taken place. However, the wares were fired in a primitive open pit, so the knowledge of constructing a kiln that could achieve and sustain a temperature high enough to fire stoneware was obviously not yet known.

Another Mon settlement produced a distinctive type of unglazed pottery called 'Haripunchai' ware, an ancient name for the area in northern Thailand where the pieces are believed to have been made. They were probably an outgrowth of the Dvaravati pottery tradition but the wares are entirely different. They consist mainly of heavy jars potted from a coarse clay. A moulded base is common, with geometric designs incised on the body and neck.

Unglazed pottery produced in Laos in the ancient historic period has been identified through an analysis of pieces recovered from a chance discovery of a kiln located outside of Vientiane, the modern capital of Laos. The site is dated between the sixteenth and nineteenth centuries. Earthenware vessels, sometimes called Luang Prabang ware, are very thinly potted with elaborate carved and moulded surface decoration. The shapes are primarily bottles used as containers for drinking water at home and at temples. The porosity of earthenware is generally a desirous characteristic for water vessels because it keeps the water cool but these bottles have a unique stone-like finish that makes them non-porous.[1]

In many parts of the region, such as Cambodia, Laos, and Thailand, contemporary counterparts for ancient unglazed vessels are made today. It is likely that the production of

[1]Cheeseman, Patricia, *Living in Thailand*, Bangkok, Media Transasia, September 1981, pp. 35–40.

earthenware pottery made in villages for local use has continued throughout history. Many of the functions of agrarian life in South-East Asia have remained the same for centuries and the need for pottery vessels has probably persisted continuously also.

The transition from low-fired earthenware to high-fired stoneware originated in China in the first millennium BC. At some time between the first and third centuries AD, the technology required for producing stoneware reached Vietnam. When the transition took place in other parts of the region is uncertain, but excavated storage vessels confirm that stoneware was made in Cambodia by the eighth century. The jars were thrown in two parts on a potter's wheel and joined together with a clay coil.

Stoneware, more than any other type of pottery, is associated with South-East Asia. Using available local materials and improved technology to produce a high-fired, hard, durable, and non-porous ware, the potters of the region provided a ware essential for daily life in an agrarian society. Above all, stoneware is a practical pottery with a broad range of uses in daily life, encompassing storage and cooking. Variations in the clay throughout the region affect the end product, providing an intriguing individuality, for no two pieces are alike. They reveal a freedom of form with no restrictions to preciseness. Irregularities in shape, glaze, and colour abound to create a pleasing aesthetic response. Changes in texture show strength and character.

Shards of unglazed stoneware excavated at a temple in north-eastern Thailand dated to the mid-eleventh century. Since glazed stoneware was made in Thailand by the tenth century, this find provides evidence that the production of unglazed stoneware continued after glazed wares were being made. However, the quantity diminished and the shapes were limited to utilitarian, upright vessels.

Late Haripunchai ware (thirteenth–fifteenth centuries) produced by the Mons in northern Thailand is unlike any other pottery yet found in Thailand. Complex globular jars with straight necks and flat feet were potted from reddish-orange or brown clay. Drinking vessels with straight spouts are also common. Detailed, incised designs were carefully executed. Sometimes a whitish clay was inlayed to form an intricate all-over pattern.

Stoneware jars and bowls have also been excavated from Ban Tao Hai, a kiln site in Laos. Handles, either button-like or animal-shaped, placed on each side of the shoulder, are typical. The vessels have a distinctive decorative feature—closely spaced incised wavy bands around the shoulder.

One peculiar stone-like shape, a pipe head, has been found in Burma, Laos, and northern Thailand. It is grey or black and, sometimes, traces of a glaze remain. The carved and moulded form is typically decorated with an intricate design which often includes one or two bands of lotus petals around the mouth and a bird-like head on each side of the pipe (Colour Plate 2).

KENDI

The kendi, an upright bottle-like vessel with a spout on the shoulder, is closely associated with the culture of South-East Asia, where it has been used as a utilitarian and ritualistic vessel since at least the eighth century. Its origin is unknown but etymology suggests India as a source. 'Kendi', a Malay word, is a derivative of 'kundika', a Sanskrit word meaning 'water-pot'. Local variations of the term 'kendi' are used in Malaysia and Indonesia today. Even though the terms are related, it is uncertain whether or not the kundika was a prototype for the kendi because their functions differ. Both are designed to be filled from the larger opening and poured from the smaller

opening but the positions of the openings are reversed on the two vessels. The kundika is filled from the spout and poured from the mouth while the kendi is filled from the mouth and poured from the spout. It seems likely that the kendi originated in India and was transmitted to South-East Asia and China by traders and religious leaders in the early years of the Christian era.

The general shape—with a round body, straight neck, and mouth—looks like a bottle. Unique features of the kendi are a spout set at an angle on the shoulder and the absence of a handle. Originally the kendi may have been a metal form as junctures of the neck and spout at sharp angles to the body are metallic features. Reproduction of the kendi in fired clay is complex, requiring skill and technology. Yet pottery kendis have been found in habitation sites in the Philippines, Indonesia, and Malaysia dating from the eighth century. Early kendi fragments have also been found in Burma, Cambodia, Thailand, and Vietnam, and, from a later date, in Laos. Even though the form must have been introduced in China at approximately the same time as it was in South-East Asia, limited shards have been found in China indicating that it was not widely used domestically. In contrast, evidence of the kendi in South-East Asia is sufficient to assume that it was used extensively throughout the mainland and insular regions.

The kendi has persevered as a ceramic form in South-East Asia over a long period of time. The earliest ones were made of unglazed earthenware and the form continues to be made of the same material today. But, in between, the kendi was produced in stoneware, both unglazed and glazed, and porcelain. Evidence of its early use in the region suggests that it was originally made locally and later imported from China and Japan. Thailand and Vietnam also produced kendis and exported them to Indonesia and the Philippines.

Kiln sites producing kendis have been found in peninsular

Thailand at Sathing Phra. Specific features of kendis from this area are a distinct white clay and a long narrow neck. The kilns may have been in operation as early as the tenth century.

Another type of kendi, previously unknown, has been found in conjunction with Sukhothai and Sisatchanalai glazed wares on sunken ships in the Gulf of Thailand. The shape is a globular body with a mammiform spout, a slender neck, and a mouth with a flange, which is reminiscent of a metal form. The clay colour is black and it is unglazed. It was probably made in Thailand during the Ayutthaya period (1350–1767). The quantity found is small in proportion to other wares. It is possible, therefore, that these kendis may have been used by crews on the ships which were carrying ceramics as export cargo (Colour Plate 3).

Insight into the purpose of the kendi is provided by ancient religious carvings in Indonesia and Cambodia, dating between the eighth and thirteenth centuries. Various scenes depict the kendi as a vessel filled with liquids, used either for utilitarian or ceremonial purposes. The form is generally sturdy and solid, making it suitable as a container for liquids, a use that is implied by the name. The narrow neck and double opening suggests that it was used for drinking. The neck is narrow enough to hold the vessel in one hand, while the spout opening is small enough for liquid to pass through without the vessel touching the lips.

Since the quality varies from weighty, crudely made earthenware to light, delicate, finely potted porcelain, the extent and duration of use must have been broad. The former most likely had a utilitarian use, whereas the latter was probably reserved for ritualistic and ceremonial functions.

A recent study of kendis classifies the form by the shape of the spout.[2] Kendis with a straight spout were made in China

[2] *Kendis: A Guide to the Collections,* National Museum Singapore, 1984, pp. 36–45.

during the Song period, in Cambodia in the eleventh century, and at Sukhothai, in Thailand, in the fourteenth century.

Unglazed shapes with a bulbous spout from the eighth and ninth centuries are depicted on reliefs at Borobudur, in Java. The bulbous spout first appeared in China in the middle of the fourteenth century. It was a popular form throughout the Ming period (1368–1644) and was produced in blue and white as well as enamels.

In the fifteenth century, kendis with animal-like append-ages were made in Thailand, China, and Vietnam. Generally, the spout is modelled like an animal's head with an opening through the mouth and a tail on the opposite side. The neck may be in the form of a rider. Features such as feathers or wings were modelled or incised on the surface of the body. Both naturalistic and mythical animal-shaped kendis were made. The Thais achieved a high degree of excellence in producing this complex form.

GLAZED

Once the kiln technology for firing stoneware was acquired, the transition from unglazed to glazed ware was a progression which probably evolved from both experimentation and the unexpected results of kiln firing. The earliest glaze was most likely a natural occurrence when ash, from the wood used as fuel in the kiln, fell on to the upper surface of a piece during firing. The ash melted and fused with the vessel forming a glaze, or glass-like covering.

The earliest glazed stoneware in the region was produced in Vietnam between the first and third centuries AD. Other countries with long-standing stoneware traditions are Cambodia, during the Khmer civilization between the ninth and thirteenth centuries, and Thailand from the tenth to the

late sixteenth century and again in the twentieth century. Glazed stoneware was also made in Burma and Laos but the dates and types of production are not clearly defined.

Imported Wares

Glazed wares for daily use have been imported into South-East Asia first and foremost from China, then later, and to a lesser extent, from Japan, for at least 1,000 years. Although trade was carried on between China and South-East Asia in the early centuries of the Christian era, Chinese ceramics were not traded in the region until the tenth century. Chinese records of the thirteenth century report ceramics being exported to areas today known as Cambodia, Indonesia, Malaysia, the Philippines, and Vietnam. Prior to this, the impetus for trade probably came from the Chinese who arrived in the region in search of luxury goods, such as ivory, rhinoceros horn, tortoise shell, spices, pearls, and exotic woods like sandalwood. Later the initiative was most likely reversed when the people of South-East Asia were attracted to the high-quality glazed wares of China.

Southern China was the point of origin for trade with South-East Asia. As demand increased in both directions for luxury items, new kilns were established in southern China, primarily in the provinces of Zhejiang, Fujian, Jiangxi, and Guangdong. Goods were transported over a network of sea routes linking the regions.

Chinese monochromes of the Song and Yuan dynasties (mid-tenth–mid-fourteenth centuries) were especially popular in the Philippines and Indonesia, whereas a limited number have been found in the mainland regions of South-East Asia. However, the introduction in the fourteenth century of a unique and decorative class of Chinese ware known as 'blue and white', attracted the entire region and it has been imported

14

ever since. The appeal for blue and white in South-East Asia continues today.

Excavated sites in Indonesia and the Philippines from the Ming period produced predominantly blue and white and it was exported in such large quantities to Ayutthaya, the ancient capital of Thailand, from the middle of the fourteenth to the middle of the eighteenth century, that divers have been working in the river for over twenty years recovering remains of the famous Chinese blue and white.

The demand for glazed ceramics, particularly blue and white, continued to grow, both in Europe and in South-East Asia. However, at the end of the Ming dynasty, in the mid-seventeenth century, China was in political upheaval and the production of ceramics for export was temporarily halted, forcing importers to find other markets. It was against this background and at this time that Japan emerged as a major supplier of glazed wares. The Dutch, having already established relations with both Japan and Indonesia, were in a fortuitous position to shift to Japan as a source of ceramics when China's supply diminished temporarily. They had access to Japan and used Indonesia as a transhipment point, with Europe as the final destination.

Quantities of Japanese export wares, primarily blue and white, have been found in Indonesia. Earlier wares were alien shapes, such as beer mugs, clearly made for the European market. They were *en route* either to Europe or to Indonesia for use by the Dutch residents.

Later, probably some time after China resumed ceramic production, a shift is discernible in the position of South-East Asia as an independent market. Finds include shapes, such as the kendi, which were made specifically for the region. Also Chinese shapes with South-East Asian designs, such as Buddhist mythical figures, have been found.

By the eighteenth century, South-East Asia was an important

market for Japanese ceramics and the trend continues in the twentieth century.

Contemporary Wares

Small village workshops are situated throughout the region producing unglazed earthenware for domestic use, the greatest number of ceramic centres being located in Indonesia, Malaysia, and Thailand. In addition to utilitarian pottery, factories in these countries produce high-quality copies of antique Asian glazed ceramics which are sold both locally and exported.

3
Uses of Folk Pottery

FOLK pottery has been used in South-East Asia for at least 6,000 years. Abundant and widespread finds of both surface shards and excavated pieces from the earth and the water substantiate a regional preference for pottery over other materials such as metal or wood. Regardless of the type, a common theme of functionalism is evident in an examination of these pottery finds.

Although historical written information is lacking, archaeological datum indicates that the primary use of pottery in South-East Asia was for the utilitarian and ritualistic needs of the local population. Pots made for funerary purposes were amongst the earliest uses. Prehistoric burials have yielded an abundance of pottery in this context. Concurrently, earthenware vessels served as containers for the storage and cooking of liquids and foods. Later uses of pottery are depicted in stone carvings on temples at Borobudur (Indonesia) and Angkor (Cambodia), dating between the ninth and twelfth centuries. Grave site excavations in Indonesia and the Philippines reveal that ceramics were used as burial wares again between the fourteenth and sixteenth centuries.

Another source for information on the use of locally produced pottery is a comparison of ancient and modern examples. The shapes of many of the vessels are the same, indicating that the functions have not changed.

The use and appeal of antique ceramics imported into the region seems timeless. Chinese wares, particularly celadons and blue and white, continue to be used in daily life today.

A popular use of antique blue and white ware is for contemporary table settings. A superb example of the timelessness

of this ancient ware can be seen in the dining-room at the celebrated Jim Thompson House in Bangkok, Thailand, where the table is set with blue and white ware (Colour Plate 4).

In Indonesia, antique ceramics are used today in association with magic potions concocted by mediums. Pottery that rings when it is struck is particularly auspicious and a piece with a resonant ring is believed to be powerful enough to summon spirits. Some believe that one particular type of saucer has the power to ward off illness and to strengthen fidelity in partners, providing the right mixture of ingredients is used and the ritual is performed by a specially gifted medium. The saucer is small, approximately 15 centimetres in diameter and is white glazed with a distinct grey tone and an unglazed ring around the centre. It is decorated with a maroon-coloured overglaze in a pattern of alternating crosshatch and floral motifs (Colour Plate 5).

Everyday Uses

Ceramic containers for storing and cooking food and liquids have been used throughout history in South-East Asia. Other shapes, such as plates, were not often produced for use locally because the region has a prevailing tradition of using other materials, such as shells, baskets, bamboo, and leaves for serving and eating food.

Every kitchen has large jars for storing liquids such as water, oil, and rice wine, and medium-sized jars for pickled vegetables and rice. Smaller containers are used for preserved foods such as pepper, lime, mango, sauces, fish paste, condiments, medicines, and cosmetics. Containers are also needed for storing lime paste, an essential ingredient in betel chewing, which is widely practised amongst the people of South-East Asia.

A contemporary earthenware pot made in Burma serves a

dual purpose. The pot is a container for rose petals and the cover is used for baking fish paste.

Large, oval-shaped brown-glazed ceramic jars are used today by the mountain people in north-eastern Cambodia, the Philippines, and Vietnam for storing a local wine made from honey, sugar, and rice. This is most likely an ancient custom since a relief carved on the Bayon temple at Angkor in Cambodia depicts men drinking through a reed from similar-shaped jars. The rice wine is prepared by placing rice husks and a fermenting agent in the jar and sealing the opening. After fermentation has taken place, water is added and the mixture is converted to wine.

Finds on sunken ships in the Gulf of Thailand include large stoneware jars with miniature glazed pots tightly packed inside. The larger jars were ideal storage containers, for although chemical elements of the sea often destroyed the glaze on the exterior of the storage jar, the small wares packed inside are in pristine condition, protected by the thickly potted, high-fired stoneware jar.

Ceramic containers are widely used for transporting water from a central source. It is a common sight to see groups of young women in Bali and other parts of rural Indonesia, and in Burma, gathered around a communal well chatting and laughing as they fill their narrow-necked, bulbous-shaped jars with water. They return to their homes carrying the jars on top of their heads or suspended from a bamboo pole (Colour Plate 6).

An earthenware bottle is a popular shape used for transporting drinking water to and from the rice fields. The porosity of the earthenware keeps the water cool for a refreshing drink during the long, hot, hard work in the fields.

An ancient custom retained today in Burma and Thailand, particularly in the north, is to provide drinking water for people walking past one's home or shop. A medium-sized

earthenware jar filled with fresh water, is placed outside as an offering of goodwill for passers-by. A ladle made from a coconut shell with a bamboo handle is used for drinking.

Ceramic mortars and pestles were made by the early Thais and Khmers. A similar shape is made today in Thailand at Ang Sila (formerly known as Ang Hin), a coastal village on the Gulf of Thailand specializing in carving mortars and pestles from a coarse, dark grey stone. Spices, including roots, leaves, and seeds, are fundamental ingredients in South-East Asian cooking and are used in almost all food preparations. Added to other staples, they provide variety in taste and texture. Selected whole seeds are placed in a mortar and beaten to a fine consistency with a pestle. The same utensils and method were used to prepare ointments, perfume, and oils, which are comparable to the use of cosmetics today.

A typical daily meal in agrarian South-East Asia consists of cooked rice, vegetables, and curry. Rice is a staple food in the diet. Pots for cooking rice are as essential today as in the past. The traditional, medium-sized earthenware vessel with a round bottom, is a universal shape. Other vessels are required for cooking fish, vegetables, and curry, as well as for preparing sauces accompanying these dishes.

Various sizes of wide-mouth ceramic jars are needed for washing. In a typical house in rural South-East Asia, an open wooden platform adjoins the kitchen. Several large stoneware jars filled with water and placed in this area are used for bathing, washing dishes and kitchen utensils, and for cleaning the interior of the house.

Jars and basins are also used as water containers for washing one's feet before entering a house. A basin filled with water is placed on the wooden or concrete platform at the entrance of a rural house. A smaller bowl floating inside is used for scooping water from the large basin.

Based on Khmer finds, it is apparent that one of the major

uses of small ceramic pots in ancient times was as containers of lime paste used in betel chewing, which is still a common practice today in South-East Asia, although less so than in the past. Traces of a hardened white or pinkish lime are found on the inside of Khmer pots, particularly animal-shaped ones.

Different types of glazed ceramic weights were made at Sisatchanalai and at northern Thai kilns. A typical form is pear-shaped, covered with a brown glaze although more complex shapes and other glazes are also known (Colour Plate 7). Suggested uses are fish-net and plumb weights.

A chess-like game must have been popular in ancient Thailand as various chess forms paralleling modern shapes have been found at Sisatchanalai, Sukhothai, and northern Thailand. Colours are subdued, just as they are today, with light- and dark-coloured pieces symbolizing Yin and Yang, the polarities. Counterparts of a knight in the form of a horse, a pawn-like shape, and a possible bishop are known (Colour Plate 8).

Religious and Ceremonial Uses

An early use of pottery in South-East Asia was for funerary purposes. Earthenware pots were buried with the dead in prehistoric times. At one site in north-eastern Thailand, over 123 burials were uncovered. The type and placement of pieces around the bodies seemed utilitarian in some instances, and in others they appeared to have a symbolic purpose. The exact meaning is unknown, but it is clear that pottery used as funerary vessels to accompany the dead into afterlife was a major purpose of pottery in the prehistoric period.

In the Philippines, earthenware jars containing bodies and other jars with just bones dating from the prehistoric period, have been found in caves. Glazed stoneware jars were used for burying the dead in Indonesia in the historic era but it was not a common practice in Thailand.

Today, blue and white folk pottery is used in a Chinese funeral ceremony (Colour Plate 9).

The religious and ceremonial uses of ancient vessels in South-East Asia are frequently depicted in reliefs on ancient temples, although the material is not readily identifiable. It may have been metal, ceramic, stone, or lacquer. However, many shapes in Khmer wares have been found that are the same as those seen on the reliefs. Metal was most likely used originally and pottery as a substitute later, or in less prosperous areas.

Ceramic vessels have been used throughout history in South-East Asian religious and ceremonial rites. Dominant ritualistic elements are candles, incense, music, dancing, drama, water, and food. Ceramic containers and offertory vessels are essential for the use of these elements. A painting of the Shwedagon pagoda in Rangoon, Burma, shows various ceramic containers in use (Colour Plate 10).

A twentieth-century report on Burma mentions small earthenware dishes used as lights. Kerosene is put in the dish and a cotton wick added. The small lamps are placed on the window sills and verandahs of houses in rural Burma on festival days.

The ancient potters at Sisatchanalai, in Thailand, produced appealing, hand-modelled animal and human figures for use as votive offerings. Spirit houses, or animistic shrines, are widely used in Thailand today, and probably serve the same purpose as in ancient times. A miniature replica of a rural Thai house usually stands on a post set in the ground and is strategically placed so that the house occupied by humans never casts a shadow on the spirit house. Offerings of figurines, fruit, and flowers are placed on the verandah of the house to appease the evil spirits and encourage them to remain in the spirit house, rather than leave and enter the owner's home.

Figures modelled from clay are used extensively in animistic

worship. Spirits for protection, fertility, and ancestors are appeased by rituals. Thai ceramic figures in human form are sacrificed in animistic rites to safeguard a person from danger or misfortune. Interestingly, the figures are nearly always seated. Many of the female figures are holding babies and it is believed these were offered as a sacrifice by pregnant women to ensure a safe delivery and a healthy child. Because so many of these figures have been found with severed heads, decapitation must have been part of the ritual.

A ceramic factory in Singapore uses a brick kiln fired with wood fuel in much the same manner as ancient times. Beside the entrance to the kiln is a small shrine. Throughout the firing, offerings are made to the spirit of the kiln to ensure a successful firing, with minimal damage (Colour Plate 11).

Architectural Fixtures

Pottery was a primary material used in ancient South-East Asia for fixtures on temples and other public buildings. Vast quantities of structural materials, such as railings, cornices, balustrades, drain pipes, and lattices were needed for the temples. Roof tiles for buildings must have been one of the most extensively made products. The most common type was an unglazed rectangular form which has been found at Khmer and Thai kiln sites. The same shape, with a white or celadon glaze, is also common. Besides flat, rectangular roof tiles, figures sculpted in the round were used as decorative fixtures on roof ridges and eaves at Sukhothai.

Glazed tiles were also popular in Vietnam, where blue and white tiles in imaginative and decorative motifs were made.

Temples at Pagan, in Burma, are frequently adorned with tiles. Typical is a row of rectangular, carved tiles surrounding the base of the temple. They depict tales of the lives of Buddha. Many of the tiles are inscribed with a row of characters along

the base and were probably used for teaching Buddhism to children.

The Khmers made finials which were most likely used as ornaments and placed at the apex on the roofs of royal buildings.

During the Bangkok period in Thailand, when Chinese ceramics were imported in great quantities, the walls of temples were inlayed with pieces of broken glazed porcelain, both blue and white, and enamels. Intricate and artistic arrangements were created. Fine examples of this technique can be seen at the Grand Palace and the Temple of Dawn in Bangkok, Thailand.

4
South-East Asian Glazed Wares

Burma

LOCATED in the north-western corner of mainland South-East Asia, Burma was a port on an ancient trade route connecting South-East Asia with India via the Bay of Bengal. The Mons and Pyus were early inhabitants of the country. The first Burmese empire was founded in the middle of the eleventh century but it was conquered by the Mongols in the late thirteenth century. Pagan, the capital, was contemporary with Angkor in Cambodia. It is known as 'the city of the four million pagodas'. Knowledge of ceramics in Burma is very limited and no cortrolled excavations have been undertaken. Yet, undocumented finds are extensive enough to suggest that Burma produced a sizeable range of ceramics, both unglazed and glazed, over an extended period of time. The types and chronology await the discovery, excavation, and analysis of the kiln sites.

Glazed ceramics evolved from an unglazed tradition established by the Mons between the first and seventh centuries AD at pottery centres in southern Burma. It is uncertain whether or not brown-glazed storage jars known as 'Martabans' were made in Burma. The port of Martaban was a major shipping point between India and China during the Song and Ming dynasties. The name was first used by Western traders who saw the large glazed jars at Martaban. However, they may have been shipped from Thailand or China.

Glazed tiles inset on temple walls at Pagan, in Burma, testify to their use as a decorative device in architecture dating between the eleventh and thirteenth centuries, a period some-

times described as the 'Golden Age' of Burmese art. Pictorial Buddhist scenes and geometric forms, such as diamonds, circles, and rectangles, dominate. The variety of shapes, motifs, and colours used for tiles are visible today at the temple ruins in Pagan. It is puzzling that the kilns for these glazed tiles have not yet been found, as a vast amount of restoration on the pagodas has taken place at Pagan.

The origin of the technology for making glazed tiles to use as temple decoration is unknown. It was most likely a post-Gupta art introduced into Burma during the period of Indianization in the early years of the Christian era. Tiles were used at Thaton, a former Mon capital. The art may have been transported to Pagan from Thaton in the eleventh century. The association of the Mons with glazed tiles seems likely since various technical words used in pottery making today are of Mon origin.

One of the earliest structures where glazed tiles have been found is the Shwedagon pagoda, built between the late eleventh and early twelfth centuries. The pagoda is comparable architecturally to Borobudur in Indonesia. Rectangular-shaped tiles depicting the lives of Buddha are set in panels around the terraces on the base of the pagoda. The figures are well proportioned and carefully formed. A narrow raised border frames the pictorial scene. Originally, the two colours, green and yellow, and the facial details, may have been clearly defined but today they are worn away by weathering of the elements.

Similar tiles are found at Ananda temple, the masterpiece of the late eleventh century. The temple is characterized by a strong Mon influence, which is reflected in the tiles. Mon script is inscribed along the base.

Glazed tiles of varying sizes and patterns are also recessed into central panels around the outside terraces of the Sulamani pagoda, a late twelfth-century structure. Circular tiles are set

into deeply moulded cornices. Each one is impressed with a band of lotus leaves. This shape is interspersed with a vertical tile shaped like the handle of a bronze axe. Tiles on the upper storey are square-shaped with a yellow lozenge in the centre and a green background (Colour Plate 12).

A register of dual-glazed tiles form a panel around the outside terraces of the Htilominlo pagoda, built in the early thirteenth century. The shapes alternate between rectangular and octagonal, providing textural contrast. Raised motifs in the centre resemble stylized lotus flowers. The exterior is green, the interior yellow. Natural elements have caused deterioration of the glaze.

The last major structure to be built at Pagan was the Minga-lazedi pagoda in the late thirteenth century. It is especially noted for its glazed tiles surrounding the outside walls of the terraces. The corners are decorated with green and yellow glazed bricks.

The tradition of using glazed tiles for decoration in temple architecture was not pursued after the Mongols captured Pagan in the late thirteenth century.

Cambodia

The Khmer Empire flourished between the ninth and early thirteenth centuries. For most of the time, the centre was based at Angkor but at the peak of power, territorial boundaries included major parts of mainland South-East Asia. A large Khmer population existed in north-eastern Thailand, and remaining evidence of Khmer civilization from this area has illuminated the ceramic production. Since the pottery was made almost entirely for daily use, the finds contribute to our understanding of everyday life.

Khmer stoneware, like the colours of nature, reflects an infinite variety of textures and hues, yet only two glazes were

used–green and brown. Sometimes the two colours were combined on a single piece. Khmer shapes are simple and appealing and include a large range of animals. Some pieces were sculpted by hand; others, such as large jars, were coil built, but the majority of wares were thrown on the potter's wheel.

The most attractive features of Khmer wares are their simplicity and individuality. No two vessels are exactly alike. Only a few natural materials and basic techniques were used. The close relationship of the clay and glaze materials with the earth is apparent in these wares. The balanced forms, with restrained decoration, express a sensitivity and an appreciation for the original qualities of clay. They reflect the functions for which they were made, and the materials that were available.

A flat base is a hallmark of the Khmer wares. On medium and large pieces, it is unglazed and roughly finished. On small wares, it is frequently in the shape of a button. A potter's cutting mark, which looks like a thumb print, is visible on the base of most small vessels.

Two classic shapes are a brown-glazed urn with a flaring trumpet-shaped mouth, and a small round pot with appendages applied to give it a bird-like appearance, which were used as lime containers for betel chewing.

Laos

Information on ceramics produced in Laos is extremely scanty and virtually no archaeological work has been carried out. A kiln site, Ban Tao Hai, located outside Vientiane, was discovered by chance during construction work while preparing the area to build a school. Seven clay kilns were identified. Nearly all the ancient shapes found are still being made today in Laos. They were primarily utilitarian wares, with an accidental glaze caused by a draught in the kiln which blew ashes

from the wood fuel on to the body of the pots. The ash melted and formed a natural, uneven glaze. The shapes were mostly jars of varying sizes with a flaring lip, mortars, and basins.

Most of the shapes were formed using a combination of the coil and wheel methods. The decoration is limited. Incised geometric bands consisting of waves are typical decoration.[1]

Thailand

Production of glazed Thai ceramics was previously thought to have started at Sukhothai shortly after the establishment of the first Thai kingdom in the mid-thirteenth century. However, the most recent evidence points to Sisatchanalai as the site where production began, approximately 300 years earlier than was presupposed. Production was centred in three regions—at Sisatchanalai (tenth–sixteenth centuries), at Sukhothai (thirteenth century) in north-central Thailand, and in northern Thailand (fourteenth–late sixteenth centuries).

The earliest glazed wares were made at Sisatchanalai and include quantities of shallow dishes decorated with the sgraffito technique and covered with a greenish glaze. These wares were the prototype for the later celadon glaze. This type of ware seems to have been made for local use only.

In the mid-fourteenth century, the repertoire of the Thai potters at Sisatchanalai included a broad range of shapes and glazes. Undoubtedly the expansion was in response to the increasing export demand, and China's temporary exit from the overseas trade market due to an imposed prohibition. It is not clear which wares continued to be made for daily use by the local people. Types that were exported have been identified through excavations in Indonesia, the Philippines, and from finds on sunken ships in the Gulf of Thailand.

[1]Cheeseman, Patricia, *Living in Thailand*, Bangkok, Media Transasia, September, 1981, pp. 35–40.

The Thais produced monochrome glazes in celadon, brown, black, and white, and decorated wares in brown and white and underglaze black. The pieces reflect the vitality and creativeness of the Thai potters. They have a distinct character and express a sensitivity that seems to have eluded the more technically developed ceramics.

Architectural fixtures such as finials, tiles, railings, and balustrades were made at Sisatchanalai beginning in the thirteenth or fourteenth century. Besides structural fittings, the architectural group of ceramics includes superb sculptural ceramics that served as fixtures on temples. Mythical figures such as a dragon-makara, a composite of a reptile and a lion, are skilfully modelled. The body is covered with a light-coloured slip and features are accentuated in dark brown or black. The contrast between the light and dark emphasizes the large scale and dimension of these sculptural figures. White monochrome miniature end tiles were modelled with exquisite detail. A leaf-shaped profile contains a pictorial composite of a praying figure in the centre surrounded by floral elements (Colour Plate 13). These dimensional architectural fixtures exhibit artistic capability in advance of their time.

The crest of potting technology at Sisatchanalai was achieved in the production of celadons, perhaps because they were made over the longest period of time. Jars, pots, and plates with a lustrous, jade-like green glaze are so admired today that the craft of making celadons has been revived at several modern factories in Thailand.

An excellent example of Thai folk pottery is a huge bulbous-shaped, brown-glazed jar used for storing water. With a sloping shoulder, short neck, and narrow mouth it looks like an inflated balloon. The size is awesome. The average height is 100 centimetres. Sometimes the glaze covers only the top portion of the body, allowing the pleasure of viewing both the glazed and unglazed surfaces. Variegated hues in clay and

glaze merge to produce a marbled appearance. Traces of a white slip can often be seen along the irregularly scalloped glaze line. Accidental glaze defects produced positive features. Frequently an appealing streaking appears in the glaze, or a thick globule trickling over the shoulder, or a yellowish tinge to the glaze that looks like a splash of sunlight (Colour Plate 14).

The wares of Sukhothai are less sophisticated technically but equally as appealing in their variation and execution of design. Types are limited and were most likely made for local use initially, later for export. Almost all the vessels are painted stoneware and shapes include plates, bowls, bottles, and small pots. Weighty and robust, the forms were potted from a coarse clay which contained impurities. The Sukhothai clay, either buff or grey, dotted with light and dark specks, is highly distinctive. The body was slipped with a white liquid clay to provide a light background for the iron-black designs that were freely painted on the surface. A clear transparent glaze, which often has a yellowish or greenish tinge, was applied over the painting. The most typical motif is the ubiquitous fish (Colour Plate 15).

A creditable range of monochromes and decorated wares were produced in northern Thailand for the utilitarian and religious needs of the local population. Major production centres were Kalong, Sankampaeng, and Phan. The decorated wares of Kalong stand out for their quality of workmanship and beauty of design.

Vietnam

Vietnamese, or Annamese, wares developed under the tutelage of China and thus reflect similarities in style and parallels in production. Kiln sites have not been identified and archaeological information is absent, so knowledge about these wares has been assimilated primarily from pieces found outside

Vietnam. Therefore, little is known about the folk pottery of the country. Since the first century of the Christian era, Vietnam steadily produced quality ceramics for domestic use. Wares were being made for export by the fourteenth century and Vietnamese ceramics competed in international trade, especially to South-East Asia, as evidenced from finds in Indonesia, the Philippines, and on sunken ships in the Gulf of Thailand.

Vietnamese wares include a wide range of types—monochromes, underglaze black, underglaze blue, and enamels. Although many of the Vietnamese wares resemble Chinese types, they are distinct. Pieces found in South-East Asia are characterized by a clay with an ivory tinge. On blue and white pieces, the foot is often disproportionately tall and the glaze is crackled with a greyish-white tone. Most characteristic of the Vietnamese wares exported to the region, is a chocolate-coloured wash on the base which occurs on approximately one-third of the Vietnamese wares made for export. The purpose is unknown. Interestingly, a similar wash is common on pieces from the Kalong kilns, which were produced at about the same time in northern Thailand. Between the fifteenth and seventeenth centuries, Vietnam made ornate blue and white altar pieces, such as vases and censers, with applied or moulded decoration, apparently for local use.

5
Imported Wares

Trade Relations

SOUTH-EAST ASIA, situated between China and the Middle East, is in a natural position to function as an intermediary trading centre for the exchange of goods. It is a region rich in natural resources, such as ivory, spices, and aromatic woods which have been coveted by foreign markets for centuries. As trade developed, the appeal of ceramics spread to South-East Asia and the region soon became a primary market for glazed wares.

Although South-East Asia was known to foreign traders since the Han period (206 BC–AD 221) and some Chinese ceramics were imported into the region in the early centuries, a significant pattern of ceramic trade between China and South-East Asia did not develop until the tenth century. Trade with China expanded and experienced its greatest level of activity in the Song and Yuan periods (tenth–fourteenth centuries). Enormous quantities of Song celadons have been excavated in Indonesia and the Philippines, especially in coastal settlements.

The introduction by the Chinese in the fourteenth century of a new type of ware–blue and white–attracted a wide market. It was immensely popular in South-East Asia and remains so today. Import of blue and white into the region reached a peak between the late fifteenth and seventeenth centuries. Large quantities were also imported between the late eighteenth or early nineteenth and early twentieth centuries when folk pottery was commonly used throughout South-East Asia.

Europeans began trading with China in the sixteenth century. The Portuguese were the first to arrive and were soon followed by the Dutch, English, and French. They soon established trading posts in South-East Asia and although their entry into the market caused fluctuations in the types of ceramics traded, South-East Asia remained one of China's primary markets for folk pottery. Production of a coarse type of ware for everyday use continued for export to South-East Asia, and during the sixteenth and seventeenth centuries ceramics were the leading export from China to the region. The popularity of folk pottery did not diminish as is evidenced by large quantities of nineteenth- and early twentieth-century blue and white found in the region. In the seventeenth and eighteenth centuries, Japan captured some of the ceramic trade to South-East Asia by producing a competitive type of blue and white, as well as polychrome wares.

Chinese Wares

YUE WARES

Yue wares are forerunners of the celadons produced in China, in Zhejiang Province. Although a proto-Yue ware existed as early as the Han period, the term 'Yue' was firmly associated with a particular type of ware for the first time in the Tang period (618–906). Pieces of Yue ware have been found in Indonesia, the Philippines, and peninsular Thailand. A light grey stoneware body is covered with a thin pale-green glaze which usually has a brownish or greyish tinge. Small, shallow bowls with incised and floral designs are typical. An attractive feature is the textural interest created by the thin glaze that collected in an irregular pattern to form thick, dark areas.

Yue-type wares were produced in various kilns in southern China after the Song capital moved from northern China south to Hangzhou, in Zhejiang Province. They were ex-

ported to South-East Asia between the twelfth and thirteenth centuries. Yue-type wares are frequently confused with the Yue wares of an earlier date.

Under royal patronage, the kilns of southern China flourished and the court encouraged trade. Within this environment of development and expansion during the thirteenth to mid-fourteenth centuries Longquan, or southern celadon, dominated exports to South-East Asia.

CELADON

Definition of the term 'celadon' is controversial, but it is identified with a type of stoneware fired to a high temperature in a reducing kiln atmosphere, and covered with a green glaze that contains a percentage of iron.

Celadon originated in China and was never made outside of the orient. The unctuous green colour simulates jade. Celadon received wide acceptance in South-East Asia. A piece of celadon was highly regarded, so much so that in Indonesia it was considered to have magical and curative powers.

The earliest celadon found in South-East Asia was produced in Shanxi Province beginning in the late tenth century. Northern celadon is a grey-bodied stoneware. Examples found in Indonesia, the Philippines, and peninsular Thailand are characterized by distinct brownish tones in the green glaze. A typical form is a small bowl, similar to Yue ware, except that it is less shallow, with incised designs depicting the peony and lotus.

Longquan celadon was produced in southern China in Zhejiang and Fujian Provinces. The quality and beauty of this ware were unequalled between the thirteenth and mid-fourteenth centuries. It has a light-grey stoneware body and an opaque green glaze with greyish or bluish tinges. The ultimate colour goal was a bluish-green but kiln conditions were not

uniform and variations were extensive. A distinguishing trait of southern celadon is a bright reddish foot. Plates, bowls, and small pots are the most common shapes found in South-East Asia. Yuan-period (1260–1368) plates of exceptionally large size, with a foliate rim and incised designs, are found throughout the region. The pieces seem to have been mass-produced as they are characterized by an untidy and rough surface on the base, evidence of a hastily finished piece. Generally, decoration was minimal, but it increased in proportion to production, and by the late fourteenth century it was quite elaborate. Also characteristic of many plates found in South-East Asia, is an unglazed ring on the base, presumably to facilitate firing. Frequently the unglazed area is so large that only a spot of glaze appears in the centre of the base.

An innovation seen on some of the celadon shipped to the Philippines, was the addition of dark brown spots deliberately created for a decorative effect by painting spots with iron pigment on the surface before glazing.

BROWN WARES

Although brown-glazed Chinese wares are found in abundance in South-East Asia, especially small pots from Philippine grave sites of the thirteenth century, little is known about their provenance and date. A 1985 report on trade ceramics found on Tioman Island in Malaysia, included small upright shapes and basins in various tones of brown with impressed designs.[1] They were made at Xicun kilns in Guangdong Province in the Song period. The Quanghou kilns in Fujian Province produced pots with a homogeneous glaze and a whitish clay. The colour of the glaze ranges from brown to olive, caramel,

[1] Southeast Asian Ceramic Society (West Malaysia Chapter), *A Ceramic Legacy of Asia's Maritime Trade*, Singapore, Oxford University Press, 1985, p. 95.

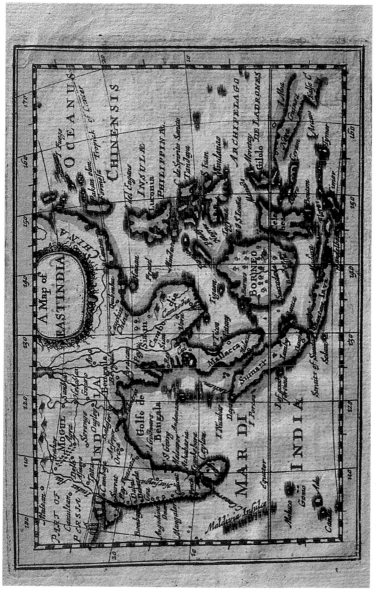

1. A map of East India; Giovanni Botero (1599); 12.0 × 5.8 cm.

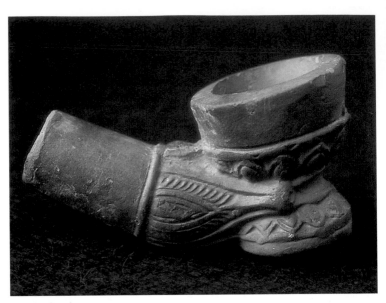

2. Pipe head; l. 7.5 cm.

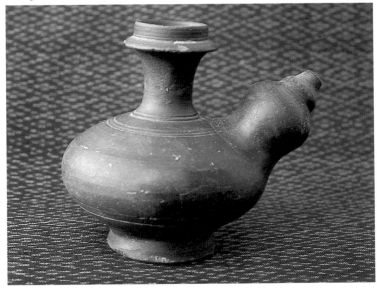

3. Kendi; ht. 10 cm.

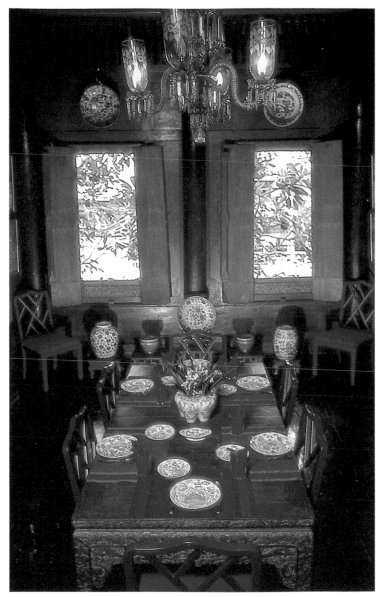

4. The Jim Thompson House, Bangkok, Thailand (John Everingham).

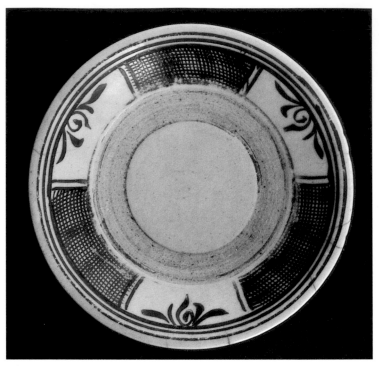

5. Enamel plate; Chinese; diam. 16 cm.

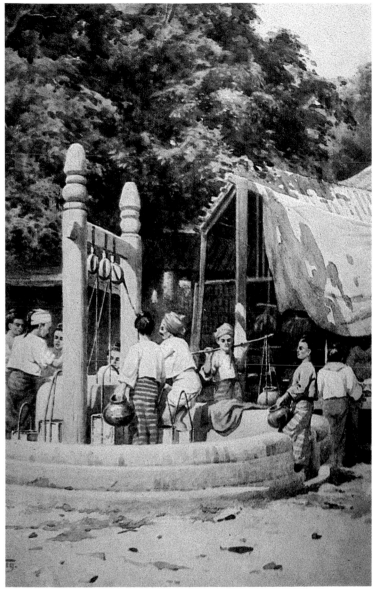

6. At the Well, Burma (Kelly, 1912).

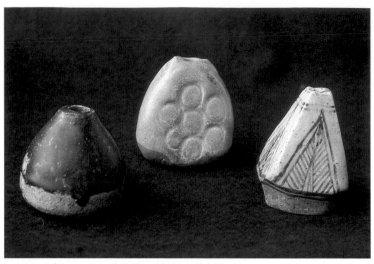

7. Weights; Sisatchanalai, Thailand; avg. ht. 6 cm.

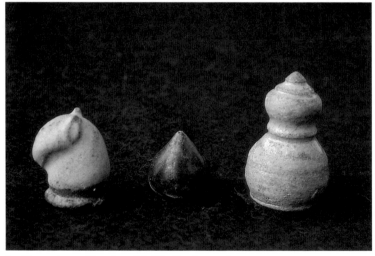

8. Chess pieces; Sisatchanalai, Thailand; avg. ht. 2.5 cm.

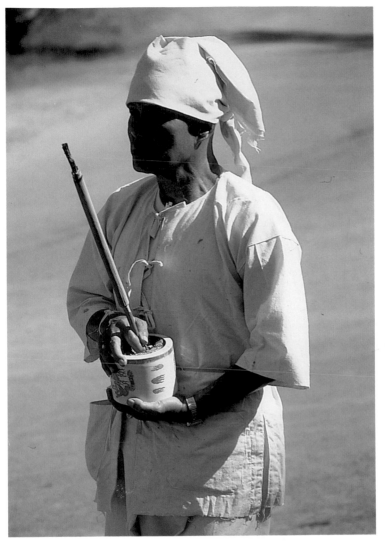

9. Funeral ceremony; Nan Province, Thailand (John Everingham).

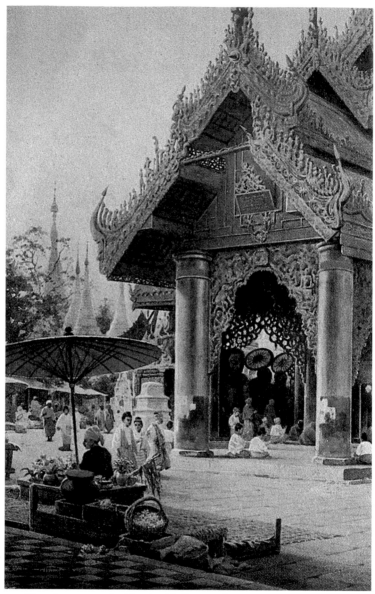

10. Shwedagon pagoda, Burma (Kelly, 1912).

11. Sam Mui Kuan Kilns, Singapore (Cris Kellstrom).

12. Tiles; Sulamani pagoda, Burma (James Rooney).

13. Tile; Sisatchanalai, Thailand; ht. 13 cm.

14. Jars (Sisatchanalai, Thailand); Garden at Tao Hung Thai Kilns, Ratchaburi, Thailand (Vance Childress).

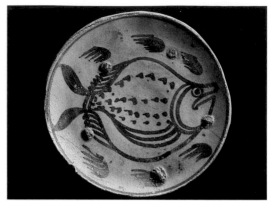

15. Fish (shard);
 Sukhothai,
 Thailand.

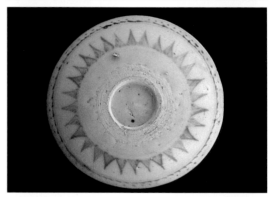

16. Hole-bottom
 saucer (base);
 Chinese; diam.
 10 cm.

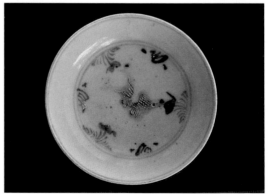

17. Hole-bottom
 saucer; Chinese;
 diam. 12 cm.

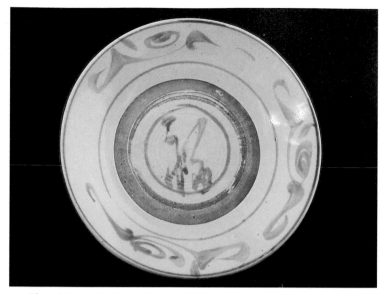

18. Plate (blue and white tableware); Chinese; diam. 28 cm.

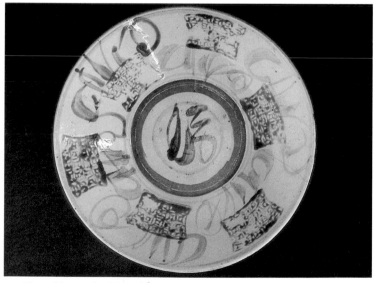

19. Plate (blue and white tableware); Chinese; diam. 27 cm.

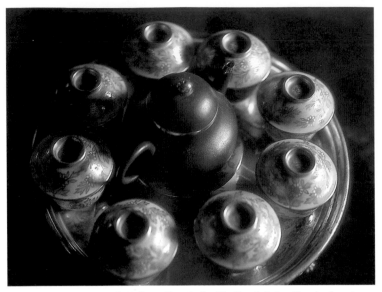

20. Tea set; Vimanmek Palace, Bangkok, Thailand (John Everingham).

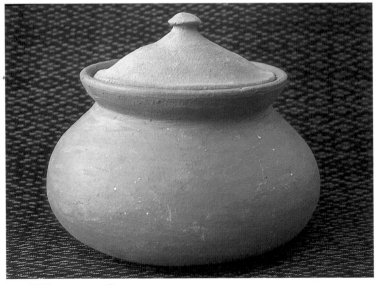

21. Utilitarian pot; diam. 13 cm.

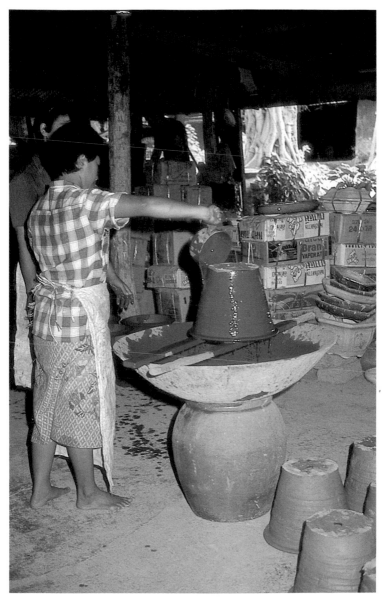

22. Glazing; Tao Hung Thai Kilns, Ratchaburi, Thailand (Vance Childress).

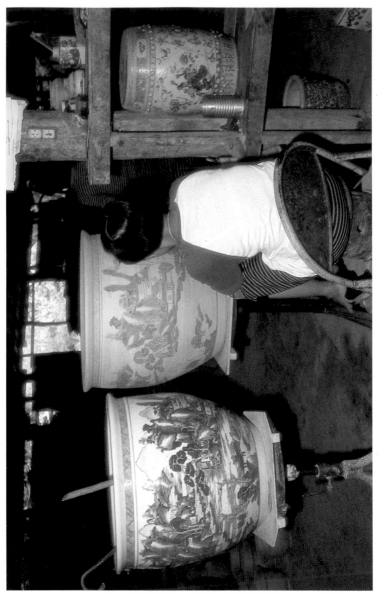

23. Copying a design; Tao Hung Thai Kilns, Ratchaburi, Thailand (Vance Childress).

and almost black. These types are similar to finds in the Philippines and Indonesia.

Hole-bottom Saucer. A small yet distinct class of Chinese export ware made between the fifteenth and seventeenth centuries has been excavated in South-East Asia. Known as a hole-bottom saucer, a somewhat misleading name, it is distinguished by the absence of a foot-ring and the presence of a recessed base surrounded by an unglazed ring. The name 'hole-bottom' is derived from this unique treatment of the base (Colour Plate 16).

Both stoneware and porcelain saucers were made. The shape is a simple curved profile with rounded sides and a straight rim. The average diameter ranges from 8–13 centimetres, although several very large examples have been found in Indonesia and Thailand. Most hole-bottom saucers are blue and white but monochromes and overglaze enamels are also known.

Like other types of coarsely made and hastily finished Chinese wares, the hole-bottom saucer almost always has flecks of sand on the interior or exterior. They occurred accidentally when a draught blew sand from the floor of the kiln on to the melted glaze.

The kiln sites have not been found but it seems likely they were located in southern China. The form was first discovered in grave site excavations in the Philippines. Until the 1970s, the form was unknown elsewhere. Subsequently many examples have been found in grave sites in South Sulawesi in Indonesia, in excavations at Brunei, and in the river at Ayutthaya in Thailand. The pieces are identical in clay, shape, glaze, and decoration to those pieces found in the Philippines. Therefore,

it seems that the hole-bottom saucer was made for export to all South-East Asian markets.

The use of the form is uncertain. Because it has been found in grave sites, it must have had special significance; perhaps it offered protection from evil spirits. Interestingly, in Philippine excavations, twice as many saucers were found in children's graves as in adult ones. Another conjecture is that it was an oil lamp to provide elevated lighting at festivals and ceremonies. A bamboo pole could be fitted into the recessed base; then a wick and oil could be put in the saucer. A similar type of aluminium lamp is used in South-East Asia today.

A few key motifs dominate the blue and white type. The placement is divided into a primary central design, which is always enclosed by one or two thin rings, and secondary border and exterior motifs. Central patterns include a cross and scroll, a composite of repetitive Sanskrit-like letters, a *shou* (longevity) symbol, a single open floral medallion, a bird perched on a branch with blossoms, and an unglazed fish. The most common motif on the exterior is a circle of tall, rectangular-shaped leaves with spiky tips radiating from the unglazed ring to the lip. The pattern looks like the spokes of a wheel (Colour Plate 16).

The unglazed fish, surrounded by a water-weed pattern in underglaze blue, is of special interest. The technique used to apply the fish enables precise dating. It first appeared in the fourteenth century. Also, the single fish surrounded by the water-weed motif was produced at perhaps an earlier date by the Thais at Sukhothai and Sisatchanalai. It has been suggested that this motif may have been a Chinese attempt to copy the fish design produced by the Thais (Colour Plate 17).

Monochrome hole-bottom saucers are either white or green glazed. They are usually more thickly potted, heavier, and generally of poorer quality than blue and white examples.

The glaze is crackled and the foot is roughly finished. If decorated, a single design was stamped or incised in the centre.

Folk pottery (eighteenth–early twentieth centuries). Vast quantities of blue and white folk pottery for daily use were produced in southern China between the late eighteenth and early twentieth centuries. Two circumstances occurred to support a large production of ordinary ware.

First, by the eighteenth century Europe, which had been a major market for China, was producing blue and white in sufficient quantities to meet its own demand. This change in trade forced China to concentrate on developing regional markets and altering production to meet their requirements. Blue and white folk pottery was the favoured type of ware. It was shipped from China to Malaysia, Indonesia, the Philippines, Thailand, and the Straits settlements of Penang, Malacca, and Singapore. The quality varied from crude, hastily finished pieces to fine wares with carefully executed detail. The impact of this type of ware was so effective that its use extended to all classes of people and encompassed royalty as well as commoners.

The Chinese were skilled at producing wares from drawings. Thus, a unique market emerged and pieces were made to order for the South-East Asian market. A fine example of these wares can be seen at Vimanmek Palace in Bangkok, Thailand, where King Chulalongkorn (Rama V, 1868–1910) lived for six years towards the end of his reign. The King was a keen collector of Chinese blue and white altar pieces. A vintage photograph of the interior of Vimanmek Palace taken at the beginning of the twentieth century shows Chinese ceramics decorated with the King's initials (Plate 1). The palace has been restored and is open to the public.

Blue and white folk pottery became immensely popular as

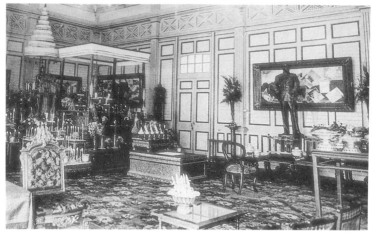

1. Vimanmek Palace, Bangkok, Thailand (John Everingham).

it was attractive, colourful, less expensive than other ceramics, and durable, because it was thickly potted. The popularity of this type of ware continues in the twentieth century as is evidenced by the production in China of many of the same shapes and imitations of the Chinese wares being made at local potteries in South-East Asia.

Secondly, in the middle of the nineteenth century, the Chinese were migrating in large numbers to areas further afield than ever before. It is indeed finds at sites, such as on the Pacific Coast of North America from the mid-nineteenth to early twentieth century, which provide useful sociological information. The Chinese took blue and white ware with them for daily use. It seems that, at this time in production, distinction was not made between the type of blue and white made for export to South-East Asia and the type made for domestic use in China.

Since so many of these wares have been found in South-East Asia, the kilns were probably located in southern China, near ports for ease of shipment abroad. Guangdong, Fujian,

Zhejiang, and Jiangxi Provinces all produced blue and white folk pottery.

Dating these wares is difficult because of the lack of archaeological information and the long-standing patterns, many of which continue in modern production.

Evidence that this type of ware continued to be imported in Thailand in the early twentieth century, is provided by W. A. Graham, former President of The Siam Society, in a paper delivered to the society in 1922. He said, '... common people use today the rough cheap Chinese crockery of the period, the flow of which into the country continues unabated'.[2]

A prevalent nineteenth-century pattern is a composite of sweet pea blossoms linked together by a thin-lined scroll. It is often found in conjunction with Chinese characters that mean 'double-joy', painted with a broad brush. This design is particularly suited to small jars with a broad base used for storing salt, rice, or tea. A variety of shapes with this pattern continued to be made in the early decades of the twentieth century. It is a delightful expression of well-made Chinese folk pottery and examples in good condition can still be found in the region today.

The sweet pea blossom and scroll motif in underglaze blue often appears on bowls with a brown-glazed exterior. A broad central area is decorated with a diaper pattern. A flat rim is a distinctive feature. The form was imitated by the Japanese, and both types are available today in the antique markets of Thailand and Indonesia. The Japanese examples are identified by a darker, blue-black colour and fuzzy lines where the glaze has run. This type of bowl was used in Java in the eighteenth and nineteenth centuries to make a sauce using soy beans and salted duck eggs.[3]

[2]Graham, W. S., 'Pottery in Siam', *Journal of the Siam Society*, 1922, Vol. 16, No. 1, p. 35.

[3]Adhyatman, S., *Antique Ceramics Found in Indonesia, Various Uses and Origins*, Jakarta, Ceramic Society of Indonesia, 1981, p. 370.

A shape sometimes called an apothecary bowl appears in abundance in South-East Asia. The name is based on examples excavated from the Pacific Coast of North America, where Chinese settled during the Gold Rush period, which show evidence of abrasive wear on the interior, presumably from the grinding of herbs and other medicinal preparations. The exterior is decorated with a hastily drawn prunus and floral spray design.

Blue and White Tableware. A particular type of Chinese blue and white ware has been found in large quantities in Indonesia, the Philippines, and Thailand. It consists almost entirely of heavily potted plates and bowls in varying sizes. Hallmarks are an unglazed ring around the centre on the interior, a white glaze with a blue, green, or grey tinge, blue painting that may have a black or grey tone, and a light grey or buff clay with visible darker specks. Sometimes the clay is reddish, caused by an accidental reducing kiln atmosphere.

Several names have been associated with this type of ware. All are misleading. The most common are 'Hong Kong' or 'Shanghai' ware, or 'Kitchen Ch'ing'. The first two probably derived from the idea that it was made in Guangdong Province, but it was also made at Dehua kilns in Fujian Province. The third name is based on use and proposed dating. However, some of the plates are most likely older than the Qing period (1644–1912) since pieces were found on the *Witte Leeuw*, a Dutch trading ship that sank in 1613.[4] For the time being, blue and white tableware seems an acceptable compromise as a name for this particular type of Chinese folk pottery.

The unglazed ring on the inside is evidence of mass production. It was deliberately left unglazed to conserve space in

[4] Van der Pijl-Ketel, C. L. (ed.), *The Ceramic Load of the 'Witte Leeuw' (1613)*, Amsterdam, Rijksmuseum, 1981.

the kiln, whereby plates could be stacked on top of one another for firing. The shape of the foot is characteristically bevelled inwards. Sand flecks on the base, which adhered during firing, are common.

The designs are lively in a folk art style. The space around the centre is the most decorated. Designs expand or contract, swirl or straighten, but always are free of rigidity and exactness.

An abstract interpretation of a floral pattern is typical. This motif is one of the most aesthetically satisfying. Painted with a broad brush, leaves intertwine with stems as the design undulates in a graceful manner around the plate, leaving undecorated spaces for balance (Colour Plate 18).

A distinctive stamped pattern is a rectangular, geometric shape resembling a textile pattern. The most common arrangement is six stamps repeated in a circle around the interior. They are staggered–three close to the rim and three close to the centre (Colour Plate 19).

Another typical stamped design found on smaller plates (average diameter 16 centimetres) is a rosette with spiky edges; three imprints are evenly spaced around the centre.

The exterior is usually undecorated except for one or two narrow blue rings painted around the rim and the base.

A visual treat on some examples is decoration in two colours of blue. The central motif, which is often a hastily executed indistinguishable Chinese character, is light blue, resulting from a pigment containing cobalt, and the design around the centre is blue-black, painted with a manganese pigment.

YIXING WARE

Yixing is a particular type of stoneware produced in Jiangsu Province, central China. Named after the area where the

pottery is made, the most famous form is an unglazed teapot in a distinctive brown colour, resulting from clay with a high iron content. The area is a rich source of fuel and of the special type of clay required for the pottery. Also, it is ideally situated near coastal ports for export of the products by sea.

Yixing kilns have been in operation since the Song period but production of Yixing teapots began in the sixteenth century and continues today. Popularity of the simple wares spanned continents. A drawing shows Chinese merchants sitting in a shop in Saigon in the nineteenth century drinking from Yixing teapots (Plate 2). They were used widely by scholars in China and were the original teapots of Europe, introduced by the Dutch when tea drinking was introduced in Europe in the late seventeenth century. The tea also came from South-East Asia where it was grown in Burma, Thailand, and Vietnam. As the popularity of tea drinking grew and spread

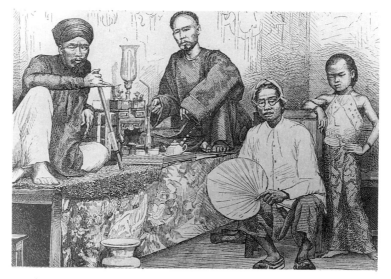

2. Chinese Merchants of Saigon (*The French in Indo-China*, 1884).

across Europe to England, tea became the main cargo transported by the East India Company. Yixing teapots were packed inside the tea leaves for protection. The teapots were exported to South-East Asia in the eighteenth and nineteenth centuries. In 1892, Yixing teapots were ordered by King Chulalongkorn to commemorate the anniversary of the Chakri dynasty in Thailand. A tea-set in Vimanmek Palace where the King lived at the beginning of the twentieth century, includes a Yixing teapot mounted with gold on the spout, knob, and lid accompanied by eight enamelled and gold cups with covers. A gold tray completes the set (Colour Plate 20). In Thailand during this period, the use of Chinese export porcelain with gold was reserved for royalty.

A Yixing teapot is made from a brown, reddish clay fired to a stoneware temperature. The colour of the clay is important, particularly since the finished vessel is unglazed. Because it is made entirely from natural pigments, the tone of brown varies, but the most common is rust coloured.

The visual appreciation is one of understatement. Its beauty lies in the simple, uncomplicated profile, and the pleasing tactile feel of the surface. The pots are designed to be used by one person so they are generally small. Tea leaves are placed in the pot and water is added as desired. The spout is constructed so that it will not obstruct the tea leaves. Traditionally, in Asia, the teapots are only rinsed with cold water. Over a period of time, this method of washing builds up a patina. This indicator of use can be a factor in determining whether or not a vessel is old.

The profile of a Yixing teapot is a most important aspect. The ideal is a small, pear-shaped form with a straight or slightly curved spout and ring-shaped handle which is the same height as the low, dome-shaped, close-fitting lid with a knob. It is undecorated with a simple, refined beauty expressed through a burnished surface (Figure 1).

Figure 1. Yixing teapot

Yixing teapots were also made in other shapes. Forms range from fruit shapes, such as the melon or pomegranate, to shapes in imitation of bamboo and tree trunks.

Pieces exported to Thailand have two unique features. First, the tip of the spout, knob, and the rim are often bound in gilt metal. These mounts are found on most of the Yixing teapots in Thailand, and it is believed that the metal was applied in Thailand as a precaution against breakage. They have only been found on teapots of the late seventeenth and eighteenth centuries.

Secondly, the surface has an exceptionally highly polished finish. The possibility that pots exported to Thailand received special handling is suggested by W. A. Graham who, in 1922, wrote that the Yixing teapots were imported in rough un-finished condition and that the polishing and mounting were done in Bangkok, near the Giant Swing. He describes how the wares were polished. The grinding or filing of the surface was done with an inferior sapphire mixed with sticlac and set hard. The final polishing was done by rubbing the pot with the outside surface of bamboo.[5]

[5] Graham, op. cit., pp. 36–7.

SHEKWAN WARE

The Shekwan kilns, south-west of Guangzhou in Guangdong Province, were established in the Song period and are still in operation. The area is rich in raw materials required for glazed ceramics, and the kilns are situated near the Shekwan River, which provides a suitable channel for transporting the wares to the coast for export.

Imitations of earlier wares, particularly Chun, are a hallmark of the Shekwan kilns. Speciality in this area originated when the kilns were established. In the twelfth century, when the northern Song dynasty was taken over by the Mongols, potters fled to southern China. Many settled at Shekwan and resumed potting. Thus, potters applied technology from northern China to raw materials in southern China. The Chun glaze, distinguished by a bluish-lavender colour splashed with purplish patches, is one of the most successful and prolific imitations of the Shekwan kilns.

Other Shekwan products are well known in South-East Asia, particularly in this century. They include an immensely popular range of appealing figurines, some life-size, and brightly coloured garden wares, such as flower pots, large jars for water, and stools. Green and brown are the traditional Shekwan glaze colours, but bright blue and yellow are also common.

Utilitarian storage vessels, such as basins and jars for storage of food and liquids, are also a major product of the Shekwan kilns today. The brownish glazed wares often have an impressed seal on the surface identifying the kiln.

Imported Japanese Ceramics

Japan has a long history of stoneware production, which was learned from the Chinese in the early centuries of the Christian era. The Japanese valued the aesthetic texture of thickly potted

stoneware with uneven, mottled glazes. In the seventeenth century, they acquired the skill of producing porcelain and, soon after, moved into the export market. South-East Asia was an attractive market because of its accessibility and because of local appreciation of the attractive blue and white ware, which was not made in the region.

Japanese blue and white ceramics are thicker and not as carefully potted as the Chinese wares. The glaze on the Japanese pieces is thick with many bubbles, and the blue has a purplish-grey tint. The painting is bold and expressive although sometimes it descends to sketchy and careless designs. Undecorated space is more common and pictorial scenes tend to be asymmetrical and less balanced than Chinese designs.

6

South-East Asian Contemporary Wares

THE 6,000-year-old legacy of antique ceramic production in South-East Asia that began in the prehistoric period, continues in the twentieth century at modern factories throughout the region. Today, the manufacturing process is refined through the discovery of additional materials, improvements in techniques, mechanization, and increased knowledge of clay and glaze chemistry. However, the basic principles of pottery and the prime stages of production—selecting the raw materials, shaping and firing the form—remain essentially the same today as in ancient times.

Types of modern ceramic factories in South-East Asia vary from small village workshops making folk pottery for daily use by the local population, to large mechanized factories producing copies of ancient ceramics and antique-style wares.

MODERN CERAMIC ALTERATIONS

An illicit branch of the type of factory producing copies of antique Asian wares has sprung up at an alarming rate in recent years. It involves altering modern copies to look like antique wares and altering antique wares to improve their appearance. Both techniques are used to increase the resale value.

Ceramic finds *in situ* instigate the idea of improving antique wares. Villagers immediately sense the interest generated by a new find and the potential monetary gain from the sale of excavated pieces. They respond by digging randomly and carelessly in the hope of producing saleable pieces. This type of work destroys archaeological data and often damages the

wares. Thus, the quality of excavated pieces is frequently poor. The next step is to alter the wares for the purpose of improving their appearance.

Modern potters are ingenious at emulating defects on an original piece. Crackle in a glaze is achieved through saturation in uric acid. The irridescent gloss on a Tang figure is duplicated by burial in the ground. Even a firing scar can be copied precisely. Chinese enamels from the Qing period are commonly repainted. These pieces are readily identifiable as the fresh paint flakes off when scraped with a fingernail or any sharp implement. Furthermore, a monochrome (one colour) can become a polychrome (more than one colour) by reglazing and refiring.

Production Centres

Village workshops producing utilitarian vessels exist in all countries of South-East Asia. The output is limited primarily to fired earthenware in sufficient quantities to meet the needs of the local population.

In some areas, potting is a cottage industry, which is a seasonal operation co-ordinated with the farming cycle. During the dry season, when farmers are not working in the fields, they make pottery. In this type of production, wares are made for immediate local use. In other areas, an entire village depends solely on the sale of pottery for economic support. The end product is used locally but production is keyed to consumer demand and is primarily for trade, either by selling or bartering, in the region.

Both men and women engage in potting, but the jobs handled by each sex vary from village to village. In a cottage industry, women usually do the potting while men do the farming and fishing. If potting is a main industry, the jobs are shared. Men gather and prepare the raw materials while

women shape and decorate the vessels. Both men and women participate in the firing process. Often men are responsible for selling the finished product.

A typical workshop is family operated. The home and factory share communal space. A one-storey wooden structure built of local products, such as hardwood and bamboo, is supported by posts. Ground level is an open airy space with an earthen floor, which is used for storing prepared clay and for shaping, drying, decorating, and glazing the pottery. The first floor is divided into rooms opening on to a verandah where the finished wares may be displayed. The kilns or pits for firing the pottery are situated near the house and are often shared by several families. Each workshop has at least one termite mound which provides a sandy, coarse clay. It is added to the clay mixture to help prevent pots from cracking during drying.

The ubiquitous, indigenous vessel of South-East Asia is a medium sized, unglazed, orange earthenware pot with a spherical body, a short, constricted neck and a flaring mouth with a thick, round rim. The base may be broad and flat, round, or attached to a foot. A dome-shaped lid with a knob in the centre is common. The size and profile vary but the general form is united by a similarity in shape, method of potting and multi-faceted use in daily life, ranging from cooking to storage (Colour Plate 21).

The basis of any pottery form is preparation of the clay. After mining, sifting out the impurities, and adding water, the clay is ready for wedging and mixing. It is essential to remove the air bubbles and achieve a uniform consistency before making a form. It does not require special equipment but it is an acquired skill. In Japan, it is not unusual for an apprentice to train for several years just learning how to mix clay to a uniform consistency before proceeding to the next step in the potting process. Large masses of clay are wedged by

bare feet. At a modern factory in Singapore, a skilled worker stands on top of a cake-shaped mound of clay. He methodically and knowingly massages the clay with utmost control. Starting from the outer rim, he kneads a section, turning it and moving in to another area (Plate 3).

To make a hand-built vessel, the paddle and anvil method is used. A potter sits cross-legged with a square, straw-filled cushion in his lap, which serves as a base to rotate and shape the clay. A wad of wet sticky clay is flattened with the palm of the hand. The walls of the pot are formed by beating the exterior with a wooden paddle while holding a baked clay anvil on the interior. During beating, the paddle is dipped in water to prevent it from sticking to the clay. This process continues until the desired shape and thickness are achieved.

On larger pieces, another jar is turned upside down to serve as a base. A circular slab of plaster is placed on top and the potter walks around the jar thinning and strengthening the walls by beating them with a wooden paddle (Plate 4). An experienced potter establishes a practised rhythm to the beating process and turns out a well-proportioned pot rapidly and skilfully.

A repetitive, geometric design is often impressed around the shoulder using a carved paddle. A pendant design, formed with a series of small nicks in the clay, is characteristic of the Ayutthaya period in Thailand (Figure 2). An incised chevron-like motif, formed with a series of thin lines, is frequently

Pendant design Chevron design

Figure 2. Impressed designs on hand-built vessels

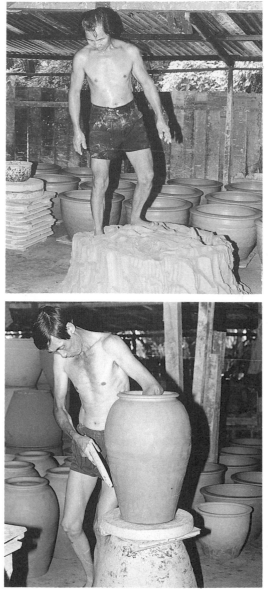

3. Mixing clay; Sam Mui Kuan Kilns, Singapore (Cris Kellstrom).

4. Beating a jar; Sam Mui Kuan Kilns, Singapore (Cris Kellstrom).

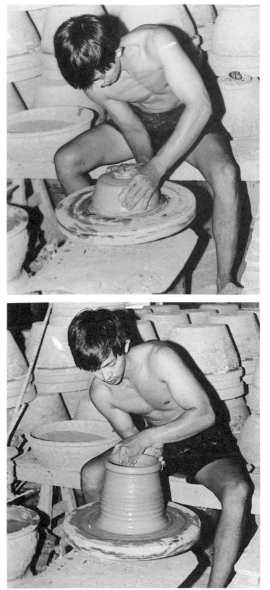

5. Centring clay on a wheel; Sam Mui Kuan Kilns, Singapore (Cris Kellstrom).

6. Raising the walls of a vessel on a wheel; Sam Mui Kilns, Singapore (Cris Kellstrom).

found on earthenwares produced in the region from ancient to modern times. Sometimes, shoe polish or oil is applied to give a smooth finish, but a more permanent and functional method of treating the surface is burnishing, or rubbing the pot with a stone disk, which gives a polished appearance and makes the pot impervious. After it is thoroughly dried in the sun, the pot is fired in a shallow pit covered with straw. This method of making vessels is one of the oldest-known crafts. It began in the Neolithic period and continues today with very little change in technique.

Wheel-throwing is the other primary method of making a clay vessel. The wheel is a circular disk, approximately 20 centimetres in diameter, which is anchored on a pivotal base. It is rotated by hand or mechanically and at varying speeds. A potter begins by centring a round lump of clay on a rotating wheel (Plate 5). Then, pressing his thumbs into the mass of clay he opens it and, by applying even pressure with both hands, he raises the walls of the vessel (Plate 6). He shapes the clay with

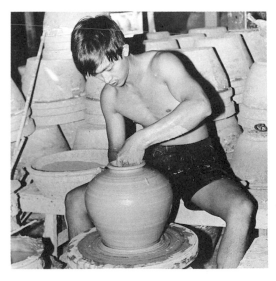

7. Finishing a vessel on a wheel; Sam Mui Kuan Kilns, Singapore (Cris Kellstrom).

his hands and tools to achieve the desired form. Finishing the lip is the final stage before removing the vessel from the wheel. Applying a steady rhythm, pressure of the fingers is used to achieve the desired shape (Plate 7). A piece that has been thrown on a wheel can be identified by a series of regularly spaced rings created by the wheel on the interior, and a pattern on the base that looks like a thumb print, resulting from cutting the vessel from the wheel.

BURMA

Burma is a model South-East Asian-type site for a modern cottage industry producing folk pottery. Reliance on pottery in daily life is paramount as substitute materials, such as plastic and aluminium, are not readily available.

At Sagaing, south of Mandalay, most of the female population of the village are involved in the production of pottery for local use. The primitive method of hand building a vessel using a paddle and anvil is still used extensively in Burma today. The village specializes in making one shape—a medium-sized earthenware container for drinking water. Many of the potters are elderly women who are not strong enough to work in the fields but, unfortunately, the younger generations does not seem to be interested in learning the craft of making hand-built pottery.

Shwe-Nyein, north-west of Mandalay on the Irrawaddy River, is another village where pottery is the main occupation. Utilitarian glazed jars and bowls of various sizes are the main products. The output is extensive and the potters are traditional as well as innovative. Shapes include ancient styles and new one, resulting from experimentation with clays and glazes. The clay is indigenous but the glaze materials are imported from the Shan state. Two other pottery centres, Keng Tung and Mong Tung, are located in the Shan state.

Southern Burma abounds with pottery centres, probably because of the availability of raw materials. Small pottery villages are Papun and Tavoy, and Bassein in the Karen state. The largest centre of pottery production in the area is Twante, south-east of Rangoon, where both glazed and unglazed wares are made. Some pieces are hand built and others are thrown on a potter's wheel. Primary glazed products include jars, flower pots, and small bowls and unglazed jars, pots, and bottles.

INDONESIA

An exemplary ceramic centre in Indonesia is located at Bandung, on the island of Java. The Ceramic Research Centre is acclaimed both for its quality products and for upholding high standards of ceramic production. Established by the Dutch in 1922 as a research institution, it aims to improve ceramic technology and artistic designs and to enhance the quality and quantity of ceramic production in Indonesia. It also contributes to the betterment of the country by providing jobs and increasing income at a local level, and by perpetuating the ancient ceramic craft. It has modernized the industry by applying mechanization to the various stages of ceramic production.

An imaginative range of unglazed earthenwares and stonewares are made at the centre. Fanciful animal-shaped containers for flowers and candles are common. The shapes and designs are created and executed by Indonesians, a system which contributes to the preservation of an indigenous, contemporary culture.

Abstract earthenware figures, both human and mythical, are a feature of kilns located at Tabanan and Kapal in Bali. Balanced and carefully potted earthenware utensils for daily use are the main product of kilns in Kasongan, Central Java.

The first blue and white wares were produced at Bandung in the late 1960s. Today, copies of antique Chinese blue and white, celadon and iron-spotted wares, as well as Vietnamese and Thai ceramics, are made at the centre. Scientific research ensures that the copies are technically and aesthetically as accurate as possible. They are sold as straightforward copies. Local materials are used for the clay and glaze, and the designs are painted by hand, in the style of Ming-period wares. However, in contrast to other ancient techniques used, most of the manufacturing process is done by machine and the wares are fired in an oil- rather than a wood-fuelled kiln.

The ability to produce high-fired stoneware and porcelain of high quality extends to East Java where the village of Dinoyo specializes in blue and white ware, sometimes decorated with underglaze red. The most recent reproductions of Chinese wares made at Dinoyo are polychrome dishes in yellow, green, and dark red. Another factory making blue and white copies of antique Chinese wares is located at Sukabumi in West Java.

The most famous modern centre in South-East Asia producing Yixing tea pots, is located in Indonesia at Klampok, Banjarnegara, in Central Java. The technique of copying Chinese Yixing tea pots is well known and accomplished in a masterly fashion in South-East Asia. Simple unglazed stoneware forms in a brownish colour, ranging from russet to purple, are reproduced today with such accuracy that it is difficult to distinguish between the copy and the original. Designed for use by one person, the small shapes continue to be admired and used today.

LAOS

A factory specializing in making pottery containers for locally brewed spirits is located in Nam Khane, north of Luang

Prabang in Laos. The production of these jars is so wide-spread that the area is called 'Whiskey Village' by the local population. Ideally situated on a tributary of the Mekong River, the brew can be easily transported and traded in other parts of the region. Ceramic water vessels are also made in the village. The black wares are commonly in the shape of a double gourd and are elaborately decorated with incised geometric patterns.

MALAYSIA AND SINGAPORE

Many of the ceramic factories in these two areas were established by immigrant Chinese in the late nineteenth and early twentieth centuries. Factories in other parts of the region, such as the pottery industry at Singkawang in West Kalimantan in Indonesia, developed in this way also. The Taiping Rebellion (1848–65) left China in a disruptive state of social order. Refugees swarmed Guangdong and Fujian Provinces, causing an excessive drain on the resources. Beset with famine, disease and anarchy, large numbers of Chinese emigrated from the southern provinces. Thus, South-East Asia benefited from the unfortunate events in China by the direct transfer of Chinese potting techniques.

Documented evidence about the everyday life of immigrant Chinese in South-East Asia between the nineteenth and twentieth centuries is beginning to emerge, and it is evident that many factories started as small family operations set up to produce ceramics for personal domestic needs. Accustomed to high-fired glazed vessels for daily use, the Chinese must have found the utensils used in South-East Asia, such as banana leaf plates and coconut shell cups, alien and unsuitable. Conversely, the colourful wares with their pristine glazes and painted motifs must have appealed to the local inhabitants of the region. Thus, an industry was born.

Unglazed pots for domestic use are made today in some rural parts of Malaysia but the knowledge and skill of potting is rapidly being lost. Daily utensils previously made of earthenware are today being replaced by metal replicas or by less expensive Chinese pottery. The ancient method of hand building is used and the potters are almost always women. Instead of a rotating wheel, the clay is shaped on a square wooden tray.

One remaining factory is in the village of Sayong in Perak. A training school has been set up to teach modern potting techniques, including the use of mechanized equipment. Some vessels are thrown on the wheel and others are moulded. All the wares are fired in a modern gas kiln.

The main product is a black, unglazed water bottle in a double-gourd shape. The two sections are disproportionate in size and the neck has a bulge. The body is decorated with a band of vertical lines, deeply incised with a bamboo knife. A distinctive feature of these water bottles is a glossy, burnished surface which is achieved by burying the pots in rice husks immediately after firing.

THAILAND

Cottage industry-type villages producing folk pottery are situated throughout Thailand. Koh Kred, up-river from Bangkok, specializes in making unglazed earthenware flower pots which are used as containers for garden plants. A typical form is a conical-shaped body, a wide mouth reinforced with a pie-shaped rim, and a base with a hole in the centre. A separate tray collects water as it drains from the pot.

Although small, the manufacturing process has the earmark of mass production. It is highly specialized, with each stage of the process being delegated to specific workers.

The clay is transported by boat to Koh Kred from a neighbouring province. It is mixed with sand and formed into

cylindrical blocks by machine. The form is thrown on a potter's wheel using a portion of the clay from the machine-formed blocks. Sometimes simple geometric patterns are incised into the semi-hardened clay. The vessel is dried in the open air for about five or six days. Then it is fired for twenty-four hours in a brick kiln which is fuelled with dry palm fronds. After firing, the colour is a bright orange.

Potteries around Chiang Mai, in northern Thailand, specialize in making a particular type of water container. It is well known for its properties of keeping water fresh and cool. The globular body has a tall neck that is built with coils. A local sandy clay is used to shape the hand-built form. A red slip is applied with a cloth and the surface is polished with a stone disk until a shiny texture is achieved. The bottle is low-fired and two colours emerge depending on the type of firing. If a kiln with a thatch roof and wood fuel is used, the bottle emerges a purplish-brown colour; if the bottle is fired in the ground and covered with sawdust, it turns black. Whichever colour, the form is one of the most popular pottery items for sale in Thailand today.

Besides unglazed earthenware, utilitarian vessels made of glazed stoneware are also produced at small village work-shops in Thailand, particularly near Ratchaburi, west of Bangkok, where the clay is ideally suited for thickly potted, high-fired vessels. These functional wares have been used for centuries with little change stylistically. The most popular type in this category is a medium-to-large brown-glazed jar for storing food and liquids. It is a container for water, fermented rice wine, oil, rice or preserved foods.

The most common form is ovoid with swelling sides, or barrel-shaped with straight sides, a thick round lip and a broad flat base, which is structural assurance of strength. The diameter of the base and mouth are approximately equal, giving the jar a well-proportioned and balanced profile. Storage capacity

ranges from 27–80 litres.

Large jars (in Thailand called *klong* jars) are ideal vessels for water storage. Strong and sturdy, they are not likely to overturn and spill the contents. The density also helps to keep liquids cool, and the thick round mouth rim enables the jar to be sealed with a cover (made of aluminium or wood) for protection from insects and dust. As many as ten or twenty large storage jars may be placed around a typical house in rural South-East Asia. Some jars are used to collect rain-water for drinking. Others, filled from the nearest natural water source, such as a river or tributary, are used for cooking and washing.

Because of its large size, the jar is usually potted in three sections which are later joined together. Alternatively, it is formed by coiling. Starting with a flat base on turntable, walls are built up to the desired height with thick clay coils. If this method is used, an irregular surface made by the coils can be felt on the interior. After shaping the form, the exterior is smoothed by beating, which also strengthens the walls. A mouth rim is added after the jar is dry enough to be handled without collapsing.

A combination of three methods may be used to decorate the jar—slip decoration, incising and stencilling. A white clay mixed with water to a liquid consistency, is used for slip decoration. Its application is unique. Generally, the slip is poured, brushed or sprayed on, but in South-East Asia a craftsman dips his fingers into the clay and rapidly paints bold designs on to the body of the jar. Then details are incised, or cut, into the clay with a pointed implement (Plate 8). Some artisans incise deftly using a comb. Auxiliary designs may be stencilled into the clay. However, this method produces a rigid look and the vitality of hand-painted motifs is lost. Sometimes the name of the purchaser is incorporated into the design using the stencilling technique.

The dragon is one of the most popular motifs. The scaly

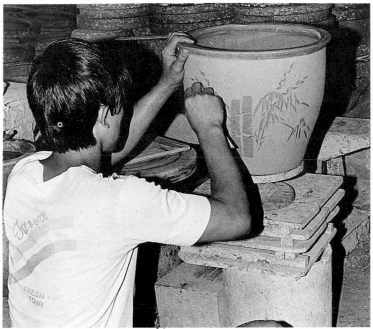

8. Incising a design; Sam Mui Kuan Kilns, Singapore (Cris Kellstrom).

serpentine body of this fabulous mythical creature coils around the middle of the jar. It looks ferocious with its large, bulging eyes, open mouth showing sharp teeth, spiky wings and bird-like claws. In spite of a fierce appearance, the dragon symbolizes goodness and is associated with protective powers and the assurance of fertility of the fields.

The main design is enclosed above and below with smaller, repetitive, border patterns (Figure 3). A cloud scroll, symbolic of rain and fertility, is one of the most popular designs. Other border patterns include stylized renditions of key fret, the sun, and flowers. Horizontal bands are used abundantly to delineate pictorial designs and to divide the decoration into registers.

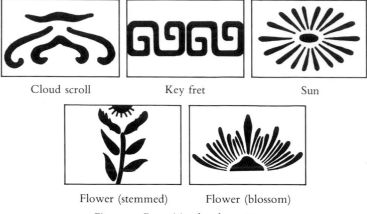

Cloud scroll Key fret Sun

Flower (stemmed) Flower (blossom)

Figure 3. Repetitive border patterns

The jars are tightly stacked in the kiln for thorough firing and to minimize damage (Cover Plate).

After firing, the shiny glazed jar emerges from the kiln with rich, golden-coloured designs against an olive brown background, a combination of earth tones which is a hallmark of these jars.

The original place of production of this type of storage jar is southern China, where it continues to be made today. Other shapes produced by the same technique include an egg jar, a medium-sized vessel for storing preserved eggs, and a wide-mouth basin used as a decorative flower container for the garden, or as a receptacle for washing one's feet before entering a home.

Antique Copies. Several modern factories in Thailand specialize in making ceramic copies that resemble antique Asian wares as closely as possible. The two largest centres of this relatively recent type of factory are in Thonburi and Ratchaburi. In both cases, the factories began as small workshops producing glazed utilitarian wares, and expanded to making blue and white and

polychromes when consumer demand for these types of wares grew. The products are for sale locally and are exported to other parts of South-East Asia, and in limited quantities to Australia.

The idea of copying older ceramic shapes, designs, and glazes originated in China, where ancient art has always commanded an exalted position of respect and reverence. Ceramics fashioned in the style of earlier pieces was a common practice, especially in the Qing period. Copies were made as a tribute to the ancient ceramic artisans. Today, abetted by improved technology and mechanization, antique shapes, designs, and glazes continue to be reproduced with artistry and assured craftsmanship. However, the motive is not always as scrupulous as it was in the past. Modern ceramic factories are commercially oriented and the sale of the end product is paramount. Reputable factories sell their wares as straight-forward copies of antique pieces and are proud of their skill at reproducing quality ceramics. Others, lured by potential monetary rewards, sell copies with the intention of deceiving the purchaser.

This problem is more prevalent with decorative porcelain, such as Ming blue and white ware and Tang three-coloured polychromes, than with folk pottery. Admired today for simplicity of shape and design, functional purpose and skilful use of natural materials, the ancient utilitarian wares never achieved a high level of acceptance in former times.

At the largest ceramic factory in Ratchaburi, copies of decorated wares are made with skill and exactness but the mainstay is the production of dragon jars. The two types operate side by side, each one using different materials, a separate kiln, and specialized workers.

The steps in the potting process are still done by hand. A jar is turned upside down and balanced on two sticks of wood across a basin. The glaze is poured over the jar and the excess

runs into a basin which sits on top of another jar (Colour Plate 22). A modern addition is the use of plastic wrapped around each jar to shorten the drying time. The dome-shaped roof of the kiln is stacked with firewood. During firing, the colour and size of the flame are carefully attended, and workmen are stationed beside the fireholes to insert more firewood to increase and maintain the desired temperature.

The painting of blue and white requires the most skilled workers. Artisans meticulously and patiently reproduce every detail of a pattern in an effort to make an exact copy. Often they have an original antique to use as a sample (Colour Plate 23).

Ban Ko Noi. A second example of a modern operation producing copies of antique wares is at Ban Ko Noi, near Sisatchanalai in north-central Thailand, where a joint Thai–Australian archaeological team has been working on an excavation of a ceramic production site for the past seven years. In an effort to involve the villagers through education about the historical value of the site, and through monetary rewards, a contemporary ceramic production centre was established. Replicas of the ancient kilns have been constructed using original materials. Workers from the local village are being taught potting skills and are producing faithful copies of celadon figures.

Chiang Mai. Another type of modern ceramic factory in Thailand produces antique-style wares, which are a combination of ancient and modern elements rather than exact copies. For example, an antique-style piece may be a composite of an old glaze and a new shape. Commercial considerations greatly influence the form, design and intended use of antique-style wares. They are sold as modern works of art with no intention of deceiving the purchaser. This element is reinforced at a factory in Thailand, where the trademark of the company and

the potter's name appear on the base of each piece. This is an ethical practice that encourages authenticity. The primary market for antique-style wares is the tourist and, to a lesser extent, the local population and the export trade.

The foremost area making this type of ware is Chiang Mai in northern Thailand, which is the centre of celadon production. Situated north of Sisatchanalai, where the original wares were made nearly 1,000 years ago, factories today closely emulate the ancient methods in an effort to turn out high-fired stoneware with a celadon glaze that resembles the high level of workmanship achieved by Thai potters.

Raw materials used to make a modern stoneware body are mined from local quarries. The clay contains feldspar, a mineral found in crushed rock, which makes clay malleable and enables it to hold a shape when formed into a vessel. The clay is thoroughly dried before being pounded into small pieces by a machine. Next it is put through a sieve to remove impurities. If the clay is coarse, the process is repeated. Water is added and the clay is soaked until enough liquid has been absorbed to give it a dough-like consistency. Then it is put into a pug mill, a mechanical mixer that kneads the clay to remove lumps and air pockets. If air bubbles are left in the clay, the vessel may burst during firing. Next the clay is put into plastic bags and set aside to mature. The epitome of modernity is revealed in this final stage of preparing the clay with the use of plastic.

Two ancient methods of shaping the vessel are used today—hand modelling and wheel throwing. The only variation in the modern system is that the wheel is driven by electricity. An additional method has been added to the modern potter's repertoire. Flat pieces, such as plates, are formed by machine to achieve a uniform size; and complex shapes are moulded, a technique that was not used by early Thai potters. After a shape is formed, it is dried in a shed for protection from the elements.

The length of time a piece is left to dry varies depending on the size of the vessel and the weather.

Decorating is done by skilled artisans who incise designs into the clay with metal tools, or brush paint with colour pigments. Floral patterns are favoured.

Today, celadon is fired twice. First, it is biscuit fired before glazing at 800 °C for approximately eight hours. This preliminary low firing makes a vessel durable, yet porous enough to absorb the glaze. Then it is painted with petrol to identify cracks. Inferior wares are broken up into small pieces and recycled through the pug mill. Perfect pieces are smoothed with fine sandpaper.

Glazing is a crucial aspect of the manufacturing process. The name 'Celadon' is synonymous with a greenish colour, and a glaze mixture containing iron oxide is necessary to achieve this colour on stoneware. It is obtained from wood ash found on the leaves of a flowering plant in northern Thailand. Other elements are added so that the glaze will adhere to the vessel. Then the gravity of the mixture is checked by a machine.

Several methods are used to apply the glaze. It is poured into a funnel to glaze the interior; the exterior is glazed by massaging the material into the clay with the hands or by pouring, dipping, brushing or spraying it on to the form. After firing, a modern celadon glaze is hard and shiny with a glassy surface. A fine crazing, caused by a poor fit between the body and glaze, is a diagnostic characteristic.

In contrast to many other types of modern ceramic factories where the firing of wares has been modernized, the firing process for Thai celadon is in the ancient tradition. Wares are fired in a tunnel-shaped brick kiln with a chimney at the rear. Hardwood or bamboo is used as fuel. The kiln is kept in operation for eight to sixteen hours and reaches a temperature of 1,250 °C. The degree of heat inside the kiln is gauged by the

amount of smoke that comes out of the chimney and by the colour and size of the flame. After the firing cycle is complete, the wares are cooled for one to four days in the unopened kiln.

It is difficult to achieve consistency in glaze colour and texture using this primitive method of firing. However, varied greenish tones and fluctuating thickness in glaze are appealing defects associated with celadon, and characteristics that have been faithfully preserved by modern Thai potters. The quintessence of the combined beauty and usefulness of modern Thai celadon is reflected in lobed, lotus-shaped bowls that can be purchased in Thailand today.

Conclusion

The folk pottery of South-East Asia spans more than 5,000 years from prehistoric times to the present. It includes both indigenous and imported wares, low- and high-fired, unglazed and glazed. Regardless of these broad parameters, the pottery has always had a single purpose—to be used in daily life by the people of South-East Asia. As a result, the wares are closely bound to the culture, the religion, and the domestic needs of the inhabitants of the region. In an area where written history is lacking and archaeological work in nascent, it is particularly significant that the folk pottery contributes towards identifying how the ancient people lived, their trade patterns, and cultural traditions. Perhaps the earthenware water jar or the glazed pot you are using today, will help tomorrow to tell the story of your life in South-East Asia in the twentieth century.

Appendix

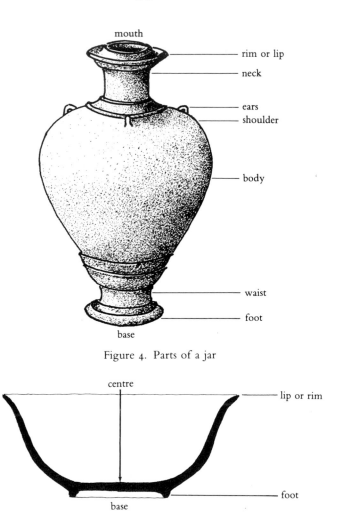

mouth

rim or lip

neck

ears

shoulder

body

waist

foot

base

Figure 4. Parts of a jar

centre

lip or rim

foot

base

Figure 5. Parts of a bowl

Glossary

Applied. Piece of clay added to a basic form, giving a dimensional appearance.

Blue and white. High-fired ceramics with a design painted in blue under a white glaze.

Celadon. Glaze with the following characteristics: an iron oxide content, a green colour, and fired in a reducing kiln atmosphere.

Coiling. Using rope-like coils of clay to make a vessel.

Folkware. Pottery made for everyday use.

Glaze. Glassy layer fused on to the surface of a pottery form.

Incising. Cutting a decorative design into clay.

Kendi. Vessel with a round body, narrow neck, and a spout on the shoulder; used as a water container.

Kaolin. White clay that is necessary for making porcelain.

Oxidizing kiln atmosphere. Occurs during firing when a sufficient or excessive supply of oxygen is available.

Reducing kiln atmosphere. Occurs during firing when there is an insufficient supply of oxygen.

Sgraffito. Decorating technique for ceramics; a slip is applied to an unglazed form and a pattern is made by scratching through the slip to expose a differently coloured body.

Shard. Broken pottery fragment.

Slip. Liquid clay; often applied to a vessel before decorating or glazing.

Waster. Pottery damaged during firing; found near kilns.

Select Bibliography

Adhyatman, S., *Antique Ceramics Found in Indonesia, Various Uses and Origins*, Jakarta, Ceramic Society of Indonesia, 1981.

———, *Modern Ceramics in Antique Style*, Jakarta, Ceramic Society of Indonesia, 1983.

———, *Burmese Ceramics*; Ridho, Abu, *White Kendis*, Jakarta, Ceramic Society of Indonesia, 1985.

Bartholomew, T. T., *I-Hsing Ware*, New York, China Institute in America, 1977.

Brown, R. M., *The Ceramics of South-East Asia: Their Dating and Identification*, Kuala Lumpur, Oxford University Press, 1977.

The French in Indo-China, with a Narrative of Garnier's Explorations in Cochin-China, Annam, & Tonquin, London, T. Nelson, 1884.

Guy, J. S., *Oriental Trade Ceramics in South-East Asia Ninth to Sixteenth Centuries: With a Catalogue of Chinese, Vietnamese and Thai Wares in Australian Collections*, Singapore, Oxford University Press, 1986.

Kelly, R. T., *Burma Painted & Described*, London, Adam and Charles Black, 1912.

Kendis: A Guide to the Collections, National Museum Singapore, 1984.

Locsin, L. and Locsin C., *Oriental Ceramics Discovered in the Philippines*, Rutland, Vermont & Tokyo, Charles E. Tuttle Co., 1967.

Medley, M., *The Chinese Potter: A Practical History of Chinese Ceramics*, Oxford, Phaidon, 1976.

Robinson, N., *Sino-Thai Ceramics in the National Museum Bangkok, Thailand, and in Private Collections*, Bangkok, Department of Fine Arts, 1982.

Rooney, D. F., *Khmer Ceramics*, Singapore, Oxford University Press, 1984.

Shaw, J. C., *Northern Thai Ceramics*, Kuala Lumpur, Oxford University Press, 1981.

Southeast Asian Ceramic Society (West Malaysia Chapter)/Oxford
University Press, *A Ceramic Legacy of Asia's Maritime Trade: Song
Dynasty Guangdong Wares and other 11th to 19th century Trade
Ceramics found on Tioman Island, Malaysia*, 1985.

Southeast Asian Ceramic Society (West Malaysia Chapter)/Oxford
University Press, *Nonya Ware and Kitchen Ch'ing*, 1981.